# LEONARDO DA VINCI
## THE MIND OF
## THE RENAISSANCE

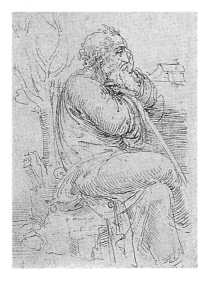

Alessandro Vezzosi

DISCOVERIES®

HARRY N. ABRAMS, INC., PUBLISHERS

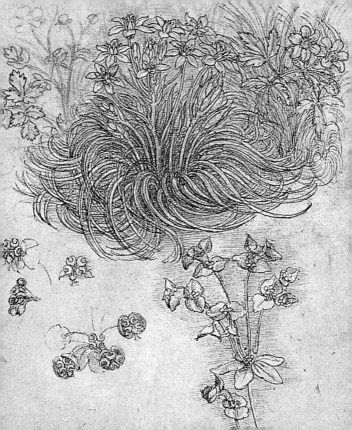

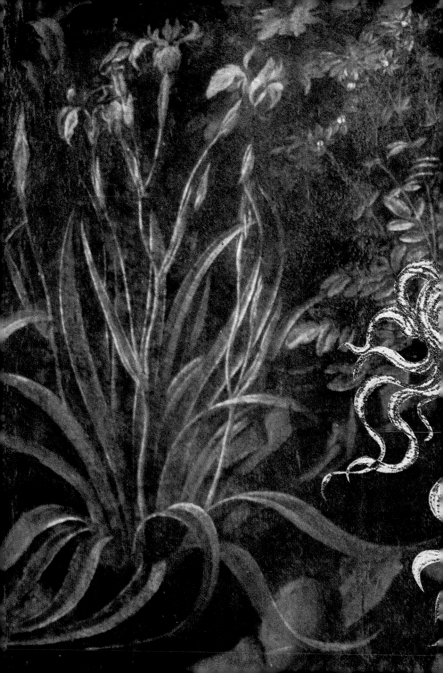

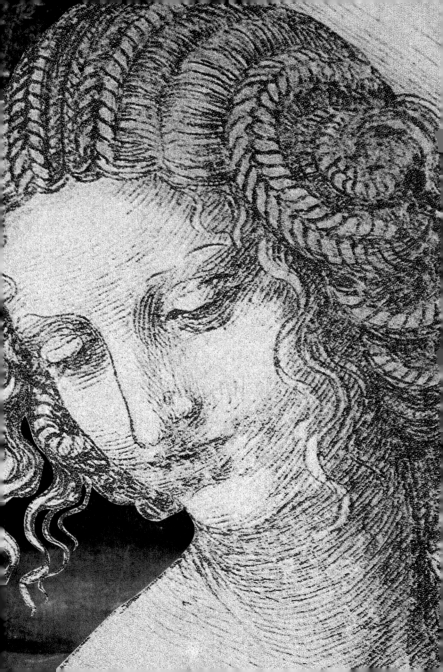

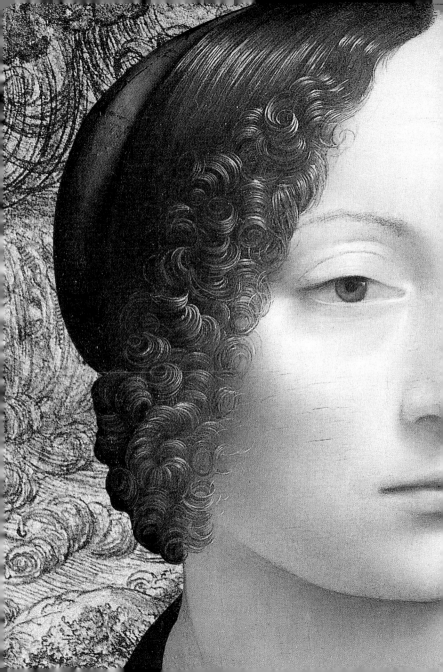

# CONTENTS

"1452. There was born to me a grandson, son of ser Piero my son, on 15 April, a Saturday, at the third hour of the night. He bears the name Leonardo. It was the priest Piero di Bartolomeo, of Vinci, who baptized him, in the presence of Papino di Nanni Banti, Meo di Tonino, Piero di Malvotto, Nanni di Venzo, Arrigo di Giovanni the German, Monna Lisa di Domenico di Brettone, Monna Antonia di Giuliano, Monna Niccolosa del Barna, Monna Maria, daughter of Nanni di Venzo, Monna Pippa di Previcone."

CHAPTER 1

# ONCE UPON A TIME IN VINCI

Leonardo, an illegitimate child himself, accompanied this anatomical drawing of a woman's womb (left) with the following remark: "A child begotten by the imperious lust of the woman and not by the will of the husband will be mediocre, vile, and dull-witted; the man who accomplishes intercourse with reluctance and disdain sires children who are irritable and unworthy of confidence." Right: an ancient bas-relief from the parish of Sant'Ansano, where Leonardo spent his childhood.

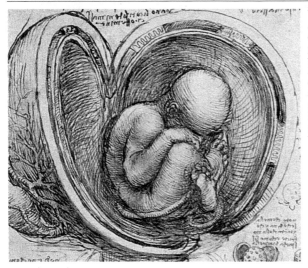

Left: Leonardo's anatomical drawing of a fetus in the breech position places it within a womb opened to show its layers and the umbilical cord, coiled in a serpentine line. The artist added cotyledons, which he had observed on the uterus of a cow.

The discovery in 1939 of a document in the Florence archives in which Antonio da Vinci, Leonardo's grandfather, confirms the child's ties to his family has cleared up a number of misunderstandings and supposed mysteries surrounding the artist's illegitimate birth and early childhood. We know the hour of Leonardo's arrival: "the third hour of the night," that is, three hours after the Ave Maria, or 10:30 PM, on Saturday, 15 April 1452. But what do we know of Leonardo?

## A love child

The child was illegitimate, but his family did not keep his birth a secret or conceal his origins; he was apparently considered a welcome love child rather than a spurned baby, born of sin. Leonardo later referred to this distinction in a commentary on a group

The notarial insignia of ser Piero (left), Leonardo's father, is simple and elegant. The title *ser* was generally reserved for notaries.

of anatomical drawings: "If intercourse is entered upon with great love and desire on both sides, the child will be of great intelligence, full of wit, liveliness, and grace."

## Two fathers, five mothers, and eighteen brothers

In the small Tuscan village of Vinci, not far from Florence, the neighbors celebrated Leonardo's birth and attended his baptism. The newborn boy was promptly taken into his father's house, which stood across from the Loggia del Comune, or town hall, and he remained an integral member of the family.

This family grew to be large and complex. Leonardo's mother's first name was Caterina, but her surname is not known. Was she "of good blood," as Leonardo's first biographer wrote? Or was she merely the daughter of a woodcutter, one "boscaiolo di Cerreto Guidi," as another source contends? What is certain is that she was a member of Leonardo's father's household.

A few months later she married, not Piero, but his friend Antonio di Piero Buti del Vacca da Vinci. He worked at

Leonardo's grandfather Antonio did not follow the notarial tradition of the da Vinci family. Although he was not a notary, he often drew up legal papers and even contracts. However, the document below, describing Leonardo's civil status in full, was written in Antonio's name by his son Piero.

the nearby pottery kiln of the convent of San Pier Martire, later rebuilt and administered by Leonardo's father and his uncle Francesco. Antonio del Vacca bore an eloquent nickname: "Accattabrighe"—the Quarreler. Caterina moved with him to the village of Campo Zeppi, in the neighboring parish of San Pantaleo, while Leonardo remained in his father's care. A little over a year after his birth, a girl, Piera, was born to Caterina, followed by four more children.

Leonardo's father was Piero Fruosino di Antonio da Vinci. In 1452 he was twenty-five years old and for at least the previous four years had been a notary, chiefly in Pisa,

Leonardo had an unusual number of godparents: five godmothers and five godfathers, all from the town, including Arrigo di Giovanni Tedesco ("the German"), the steward of the Ridolfi family, noble Florentines who owned a number of houses and a great deal of property in and around Vinci.

but in Florence as well. A few months after Leonardo's birth he married a young woman from a wealthy Florentine family, sixteen-year-old Albiera degli Amadori, who was to die in childbirth in Florence in 1464. The year after her death, Piero married Francesca di ser Giuliano Lanfredini, who died childless in 1473. Leonardo's first half-brother on his father's side, Antonio, was born in 1477; Antonio's mother, Margherita di Francesco di Jacopo, then eighteen years old, had five more children. Finally, in 1485, when Leonardo was past thirty, Piero married Lucrezia di Guglielmo Cortigiani, who had seven children. The artist seems to have been fond of her; even when he was fifty-five years old, he addressed her in the *Codex Atlanticus* as "dear and sweet mother."

## Vinci: a name and a symbol

Archival documents show that Leonardo was always called "di ser Piero da Vinci," that is, Piero's son ("ser," similar to "sir," indicates gentility, not nobility), and it is under that name that at twenty he was registered as a painter in the rolls of the Compagnia di San Luca, the artists' guild in Florence. The name da Vinci is an old one and does not indicate that Leonardo was a native of the town: had he been born in Florence, he would still have been called "Lionardo di ser Piero da Vinci." The da Vinci family (sometimes spelled Da Vinci) had been prominent in the town since the 13th century. Leonardo's great-grandfather, also called Piero (but "di ser Guido," that is, Guido's son) da Vinci, had been a well-known notary, chancellor, and ambassador of the Florentine Republic.

Vinci was an ancient, rural town situated between Montalbano and the valley of the Arno River, with a castle, the church of Santa Croce, an almshouse, and a few houses. It had been founded by the Etruscans and occupied by the Romans. "Vinci is a castle," remarks a postscript to the town's ancient constitution, "whose origins go back to those of the giants who zealously and

The name Vinci refers both to the town and to the medieval fortified castle of the Guidi counts within it. In the mid-13th century Florence acquired the castle, or *Castrum Vinci,* and held the town as a vassal. The medieval seal of Vinci (opposite) shows a castle. The fortress's functional and symbolic design is that of an elongated oval, like the bridge of a ship whose masts are the twin towers of military and religious power. This 16th-century map (left) shows the overall plan of the town, with its medieval walls, the watercourse that powers its mills, an inn (*ostaria*), a well (*pozo*), and the Loggia del Comune (the town hall). Below: the campanile (bell tower) of the church of Santa Croce at left and the castle with its tower at right.

arrogantly took up arms against Heaven, which in the end punished them and brought great shame upon them." This sentence recalls the tone of Leonardo's own fables, brief moral allegories in which he mixes scientific knowledge with popular wisdom, such as in his evocation of sea water, which strives to reach higher than the sky, but is obliged to sink beneath the earth, imprisoned for a long penance.

The name Vinci comes from the word for the rushes that grow on the banks of a local stream called the Vincio and that in the Tuscan countryside are woven and braided. This name, which evokes both his native town and his patronymic, became Leonardo's emblem: he identified himself with the interlacing *vinci* and often drew elaborate entwined knots in his notebooks and painted them as details in works such as *Lady with an Ermine* and the *Mona Lisa*. The theme of the symmetrical knot, a sort of intellectual and visual puzzle, recurs often in his art.

Above: stylized *vinci,* or rushes, became a decorative element in an engraved emblem of Leonardo's Achademia, or circle of students.

### Book learning and country wisdom

Leonardo's childhood was richer in practice than in theory. Although he belonged to a well-born notary's family, he was in direct contact with peasant culture, living in a rural world that produced wine, oil, and flour.

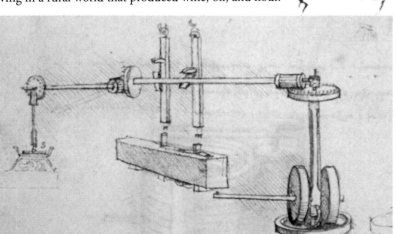

His grandfather Antonio owned lands that he worked in part himself; his favorite uncle, Francesco, had a mill, and his half-brother Giovanni grew up to be an innkeeper and butcher. The future designer of mechanical systems observed the material properties of the winds, the earth beneath his feet, and the "water which has dissolved itself in [the air] into imperceptible molecules," in order to try to understand the abstract nature of the universe.

## Left-handed thinking

From his earliest years Leonardo employed mirror writing. He used his

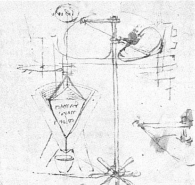

left hand and started his lines on the right—the practice of the oldest civilizations and still characteristic of Arabic and Hebrew today. In his notebooks he often filled the right page first, then the left, and his letter forms were also reversed. He did this with no intent to conceal—it was merely a fairly common quirk of perception that was not corrected when he was a child. That it was not illustrates the freedom Leonardo enjoyed, but also the limits of his literary schooling. He was, after all, an illegitimate child to whom any career requiring a formal education was closed.

Leonardo also used normal handwriting, though it was more difficult for him. He employed it for specific projects that had to be intelligible to others, such as certain maps or when he recorded his father's death in a manuscript note. In general he had others pen his official correspondence and letters of introduction. He used both hands to draw,

A talented engineer, Leonardo drew designs for mechanical crushers—precursors of industrial robots (opposite), as well as spades and stills; water mills; turbines; plows "to go straight over a long distance" and "without oxen"; systems for grinding grain or painters' pigments (top). He was a practical man: some notes on geometry break off in mid-thought with these words (above): "...etc. because the soup is getting cold."

and perhaps that ambidexterity, with everything it implies about his senses and perception, contributed to the development of his visual and conceptual gifts.

## Notaries and potters

Leonardo's paternal grandmother, Lucia di ser Piero di Zoso, who was like a mother to him, may have been the first to encourage the child's art. She was from a family of landowning notaries and potters who produced painted majolica in Toia di Baccchereto, one of the best-reputed and most active centers of art ceramics of the 14th and 15th centuries. Their pottery was at Carmignano, very near Vinci. There is evidence that Leonardo was acquainted with the art of ceramics and indeed practiced it. He is known to have gone as a child to Baccchereto, where he was familiar at least with the family kiln, which his father was to inherit. Terra-cotta sculptures, majolicas with tracery designs, and hexagonal ceramic tiles that recall Leonardo's drawings have recently been found.

Hexagonal 16th-century tiles found in the warehouses of the Iparművészeti Múzeum in Budapest (reconstruction above) apply the optical effects of some geometrical designs drawn by Leonardo on a manuscript page now in Oxford.

## In the heart of Tuscany, at the height of the Renaissance

Contrary to prevailing misconceptions, Vinci was neither isolated nor a primitive backwater. Churches in nearby Orbignano (where Leonardo's family had a house and land as early as 1451) and Sant'Ansano (the parish to which Vinci belonged) contained many fine works of art from different periods. In Vinci itself, in the church of Santa Croce, a painted wood sculpture of *Mary Magdalen* of 1455, by an unknown but talented artist, testifies to a knowledge of the sculpture of Donatello (1386?–1466).

Lying in the heart of Tuscany, Leonardo's town maintained close relations with the neighboring city of Pistoia, one of the region's great artistic centers. His aunt Violante lived there. In its church of Sant'Andrea he would have seen the magnificent medieval bas-reliefs by Giovanni Pisano (c. 1250–after 1314), with their figures' lively facial expressions and *i moti dell'animo,* the motions of the soul: the animated gestures of

Below left: on this 1503 map Leonardo drew (and identified in conventional handwriting) the places where he had passed his early years: Vinci, Sant'Ansano, Vitolini, Collegonzi, Pontorme, Montelupo. The area was an artistically rich one: the church in Vinci had a fine carved *Mary Magdalen* (opposite). This *Prophet* (below) is one of several figures by Giovanni Pisano in nearby Pistoia.

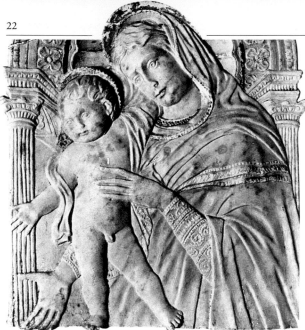

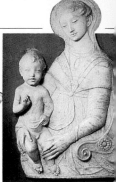

The Florentine work-shops of Donatello (left) and, Mino da Fiesole (above) probably produced these bas-reliefs of the Virgin from Orbignano and Empoli.

hands, the pointing fingers. He would have discovered, among the splendid anonymous 14th-century frescoes of the nearby church of Sant'Antonio dei Frati del Tau the eddies of a dramatic scene of the Flood—a theme of great importance in his own art. It was in Pistoia, too, that the Florentine master architect Michelozzo (1396–1472) built the church of Santa Maria delle Grazie between 1452 and 1469.

Empoli was even closer. Situated on the Arno, the city was at a crossroads between the maritime republic of Pisa, the fertile farmland of the Val d'Elsa, and the independent city of Siena, a great power center and rival of Florence. In the medieval age just ending when Leonardo was born it had also been a place of lively artistic ferment, as evidenced by the paintings of Gherardo di Jacopo Starnina (c. 1354–before 1413), Agnolo Gaddi (c. 1350–96), Lorenzo Monaco (c. 1370–c. 1425), and Masolino (c. 1383–c. 1440/47) and the sculptures of Tino di Camaino (1280–c. 1337), Bernardo Rossellino (1409–64), and Mino da Fiesole (1430–84).

## Artistic beginnings

Leonardo is recorded as a resident of the town of Vinci until 1468. He lived there most of the time, but not always, since Piero worked principally in Florence, where he was notary to the most influential families, from the Medici to the Bentivoglio of Bologna.

It seems likely that Leonardo's artistic activity began before 1469, the year in which, according to tradition, he entered the workshop of the great Florentine sculptor Andrea del Verrocchio as an apprentice. As a rule apprentices entered their masters' workshops quite young, but Leonardo was already seventeen that year. No art work by him predating this time survives. Still, art was clearly his first profession: there was a significant gap in time between this period of artistic apprenticeship and the beginning of his literary and scientific studies.

There were sixteen Romanesque churches in and around Vinci; Leonardo as a child was surely familiar with the art of earlier times as well as his own. This idealized landscape of two nearby villages, Valdinievole and Padula in Fucecchio (seen from Montalbano), is the first known autograph drawing by Leonardo. It is dated 5 August 1473, the feast day of the Virgin of the Snows, observed in several villages in the area.

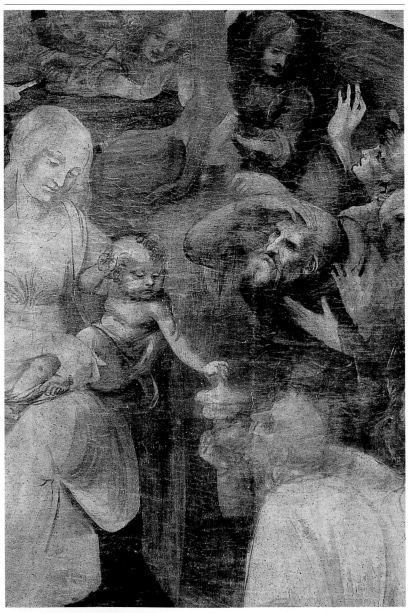

S er Piero "one day took some of Leonardo's drawings along to Andrea del Verrocchio (who was a close friend of his).… Andrea was amazed to see what extraordinary beginnings Leonardo had made." Thus it was, according to the Renaissance biographer Giorgio Vasari (1511–74), that Leonardo went into the Florentine workshop of the artist Verrocchio. There "he began to practice not only one branch of the arts but all the branches in which design plays a part," even though "he intended to be a painter by profession."

## CHAPTER 2
## IN THE FLORENCE OF THE MEDICI

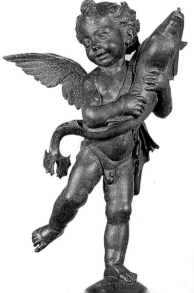

*The Adoration of the Magi* (left, a detail) is the work that best expresses Leonardo's efforts during his first Florentine period. Right: the charming little bronze *Putto with Dolphin* fountain in Florence, with its wonderful smile and dynamic spiral composition, is considered one of Verrocchio's masterpieces. It has also been attributed to Leonardo. Originally it rotated, moved by an ingenious hydraulic mechanism, expressing an effervescent vitality.

By and large, Giorgio Vasari's remarks on Leonardo in his *Lives of the Most Excellent Painters, Sculptors, and Architects* (1550, with a second edition in 1568) are reliable, despite certain exaggerated details meant to enforce the myth of the artist. Vasari wrote that Piero could quite profitably have helped the young Leonardo, who "would have been very proficient at his early lessons," had the "volatile and unstable" youth applied himself to his studies and not to studying arithmetic instead. He preferred music, but above all "never ceased drawing and working in relief," even before he met Verrocchio. This observation supports the theory that by then Leonardo already had some experience in "the branches in which design plays a part."

## In Verrocchio's workshop

Andrea del Verrocchio (c. 1436–88) was the complete artist and already famous. Vasari calls him a "goldsmith, a master of perspective, a sculptor, a woodcarver, a painter, and a musician," but he was also a foreman and contractor. He obtained contracts for important commissions that he then carried out with collaborators or consigned to his students. His workshop was legendary: in the late 1460s and 1470s some of the Renaissance's leading artists—Sandro Botticelli (1445–1510), Pietro Perugino (c. 1450–1523), Domenico Ghirlandaio (1449–94), and Lorenzo di Credi (1459–1537)—worked there, as well as so-called minor artists such as Cosimo Rosselli and Francesco Botticini. The artists of his workshop worked together on projects, and some of these show the hand of Leonardo and have been partially or entirely attributed to him—though this is a subject of some disagreement among art historians.

Clients were always requested to pay Verrocchio for all works made in his studio. This was the case, for example, with the *Madonna della Piazza* (c. 1475–85) in the Pistoia cathedral, which

It has been suggested, on the basis of the figure's idealized grace and beauty, that the young Leonardo collaborated on, or even posed for, Verrocchio's bronze *David* (below). The small predella of *The Annunciation* in the Louvre (bottom), long attributed to Leonardo, is today considered to be by Lorenzo di Credi.

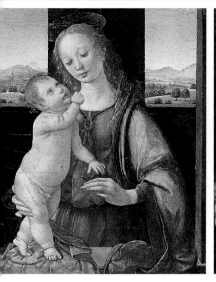
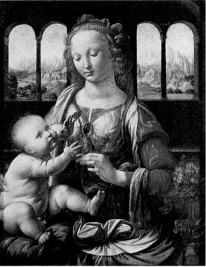

the master painted in collaboration with Lorenzo di Credi; Leonardo is supposed to have made suggestions about the composition and to have painted some of the details, as he may have done for the still-debated predella of the Louvre's *Annunciation*. Leonardo, not yet twenty, excited much admiration for his great aptitude. Both he and his fellow apprentice Perugino, two years his senior, were noticed by the painter Giovanni Santi, father of Raphael, who in his chronicle the *Cronaca Rimata* celebrated Verrocchio's skill in training talented students.

There is some question whether Leonardo collaborated on these two Madonnas. The *Dreyfus Madonna* (above, left) is of fine but uneven quality; the background landscape and figure of the Virgin are remarkable. A drawing of her drapery, now in Dresden, is attributed to Lorenzo di Credi. The *Madonna with a Carnation* (above, right) has been compared with works by Verrocchio (the vase of flowers and the hair are in his style) and by Lorenzo di Credi, but the deftness of the execution, the handling of drapery with highlights in yellow, and the chromatic variations of the landscape support the attribution to Leonardo.

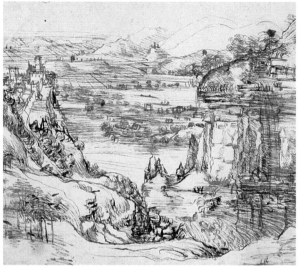

In Florence Leonardo was at the heart of refined humanism—a brilliant world of literary and artistic ferment and an extraordinary melting pot in which Tuscan tradition was enriched with a revival of interest in classicism and by new influences from the North and from as far away as Byzantium and Asia. He was inspired by his Florentine predecessors, the revolutionary painters Giotto (1267?–1337) and Masaccio (1401–28).

He was very critical of the art of his friend Sandro Botticelli. "He did some very sorry landscapes," he remarked in his *Treatise on Painting* (a collection of his various writings on the craft and theory of painting, compiled after his death). He considered these superficial, mere "cursory and simple investigation," no more interesting than the print made on a wall by a sponge. Yet in another memorable passage he advised artists to appreciate accidental and random patterns, to observe "walls covered with shapeless stains, in order to excite the mind to various inventions." But, he cautioned, this would be useful only to one already able to "execute every aspect of the things you wish to depict," a statement that for all its bold modernity still gives primacy to dexterity and skill and the exercise of technical mastery.

In Leonardo's first known landscape, volumes and space, mists and shadows are animated by strongly dynamic line drawing. The line transcribes the processes of a mind investigating artistic and scientific problems of representation; working in a poetic, exploratory mode, Leonardo attempts to penetrate the phenomena of the material world. A detail (above, left) shows animate nature: flowing water and trees moved by wind.

## 1473: the first landscape

The first work to provide a precise point of reference in Leonardo's early production is his *Landscape of Santa Maria della Neve,* a drawing that bears the autograph date 5 August 1473. It has been called "the first true landscape drawing in western art," although the Sienese painter Ambrogio Lorenzetti had painted two landscapes on wood panels 150 years earlier, and the theme had long been a common one in Asian art. But Leonardo's vision of his native region is in a different register. He referred to this familiar landscape as the most natural and instinctive archetype, including in his drawing the

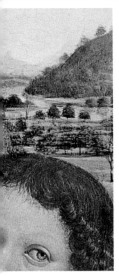

perspective of a castle (perhaps Larciano), the visual effects of the Fucecchio marshlands, and the peak of Monsummano silhouetted on the horizon. The memory of boats seems to slip from his pen, so natural are the marks with which they are sketched in; what interested him more than the description of the shapes of trees and rocks was capturing the essence of perceptual and conceptual phenomena—atmosphere and wind, snow or rain shifting through sunlight. Leonardo expressed a new sensibility about the values of light, which he caused to vibrate with hatching, giving both density and transparency to the landscape. Writing down the exact day and holiday that he was celebrating, he suggested the idea of a snowfall in the month of August, a simultaneously natural and extraordinary

In Leonardo's artistic conception, light and the elements are the true protagonists of the work of art. Great originality of thought and awareness of natural phenomena are visible in even his earliest landscapes and anticipate a number of theories that he elaborated much later in his *Treatise on Painting.* Thus, for him, air is never perfectly transparent, but rather has thickness and color. Water, "nature's vehicle," undergoes and conveys continuous metamorphoses. The artist's landscape of 1473 bears strong similarities to details of a *Madonna* attributed to Perugino (details, left and below).

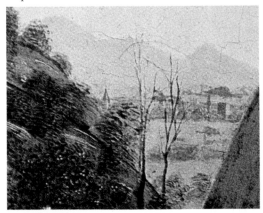

phenomenon that conflates the two extremes of the weather cycle.

## Seeking the lost works

Young as he was, Leonardo was already more than a technically proficient painter. His *Landscape* displays great innovations in the technique and emotional power of drawing, surpassing the skills of his master and his talented comrades in the workshop and rising above many of the facile formulas of Florentine painting.

How many drawings and paintings did he do in his early career before achieving such mastery? A number of modern exhibitions have explored the problem of lost works by Leonardo. We know of many through detailed documents, surviving preparatory studies, and contemporary imitative works by other artists. Intriguing discoveries are announced periodically. But many mysteries remain: for example, will the tapestry cartoon that Leonardo drew for the king of Portugal ever be found?

There are probably more surprises in store concerning Leonardo's sculpture. Though he is known to have made sculptures in his early years, no extant work can be ascribed to him with certainty and so no stylistic comparisons can be made. Documentary references to the sculpture Leonardo created in his youth present unanswered questions: where are the *condottieri,* the madonnas, and the laughing *putti* said to have been made by him? At times paintings and sculptures by Verrocchio, Lorenzo di Credi, and others have been

This remarkable *Youthful Christ* (above) has inspired a number of conflicting attributions: it may be by Verrocchio and his workshop, by Leonardo at Verrocchio's workshop, or by Leonardo in the period of *The Last Supper.*

credited to Leonardo. These works are still hard to attribute and to catalogue.

## A fantastic bestiary

In response to a request from a peasant of Vinci to Leonardo's father, the artist painted a dragon on a figwood buckler. The image, described by Vasari as a "fearsome and horrible monster which emitted a poisonous breath and turned the air to fire," has a special meaning among the lost works of Leonardo's youth, for it was his first essay in the art of the marvelous and the imaginary, a lifelong passion. Vasari tells us that he composed the monster from the features of lizards and various other real animals, constructed in a rational, scientific way. He painted the dragon theatrically, giving it a certain psychological weight, and was pleased by its effect of startling surrealism.

### "Inhabited" drapery

The practice of drawing from a model, especially for

A bas-relief of c. 1475 portraying the Roman general Scipio (below, left) resembles, in some of the details of the armor, a drawing of a warrior by Leonardo (below, right). Several such reliefs are traditionally attributed to Verrocchio, Luca della Robbia (1399–1482), and Francesco di Simone (1437–93) and sometimes to Leonardo.

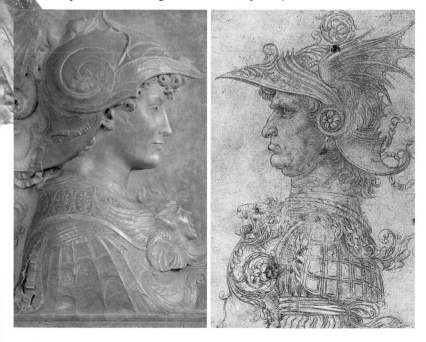

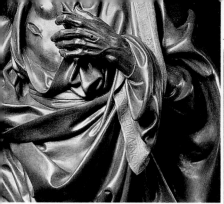

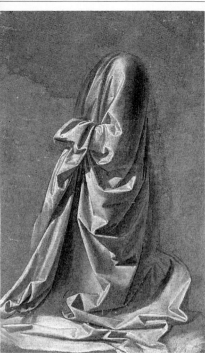

the study of drapery, was widespread in the workshops of Renaissance Florence; it was to become preeminent with the Mannerists in the 16th century. Leonardo pursued this study with great verve and, taking it beyond mere academic exercise, brought out all its latent abstraction and force in a series of monochrome sketches, done with brush and a gray wash on canvas or tinted paper, whose virtuosity filled Vasari with admiration.

The fourth part of Leonardo's *Treatise on Painting* is titled "On Dresses, and on Draperies and Folds." He notes there that a drapery "must fit the body, and not appear like an empty bundle of cloth." The echo of these studies informs the works of his maturity and is already evident in the paintings and drawings of his youth, made in Verrocchio's workshop, where anatomical models were also cast. From this early period on, Leonardo pursued not only painting and other artistic practices but research in technology and mechanics.

## Painter and engineer

In a note written in Rome in 1515, when he was trying to find a way to solder clusters of parabolic mirrors, Leonardo recalled how, forty-five years earlier, "the ball on Santa Maria del Fiore was soldered." This is a reference to the enormous copper sphere crowning the lantern of the cupola of Florence's cathedral, commissioned from

Leonardo's drapery study (above), with its sharp folds and strong highlights, recalls the sculpture of Verrocchio (above, left). Vasari writes of Leonardo: "He carefully studied drawing from life. Sometimes he made clay models, draping the figures with rags dipped in plaster, and then drawing them painstakingly on fine Rheims cloth or prepared linen. These drawings were done in black and white with the point of the brush, and the results were marvelous."

Verrocchio in 1468 and installed in 1472. At that time Leonardo had made many drawings of the ingenious machines invented by the architect Filippo Brunelleschi (1377–1446) at the cathedral building site for the construction of the huge cupola. This note suggests that Leonardo was well acquainted with the immense variety of mechanical systems devised by Brunelleschi, such as his machinery for theater sets or his patented "chariot that flies on water" (in the ironic phrase of the poet Aquettini da Prato), designed for the transportation of marble to Florence by water, but which got stuck in the Arno near Empoli.

Leonardo was acquainted with Brunelleschi's work and was influenced by the architect's large-scale projects, especially that of diverting rivers to flood Lucca during the war waged by Florence in 1428. He followed the final construction of Brunelleschi's ingenious dome for the Florence cathedral with interest. The two images below show scaffolding around the lantern at two different times: at left, around 1471, when it was first erected, and below, in 1601, when it was restored after being struck by lightning.

## To raise the baptistery of Florence

The great cathedral dome, completed when Leonardo was twenty, became the focal point of Florence's skyline. It constituted the new point of geometric convergence of the urban and sociopolitical space of the city, and its soaring shape and vast scale impressed all the aspiring architects of the age, including Leonardo.

Facing the church was a much older building (probably from the 11th century), the octagonal baptistery of San Giovanni, considered by Florentines a paragon of architectural perfection. Brunelleschi, who had drawn the baptistery in one of

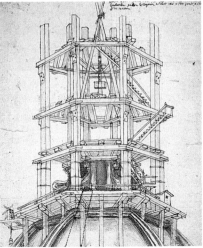

his perspective plans, also designed its Renaissance equivalent, the unfinished 1433 rotunda church of Santa Maria degli Angeli, which influenced Leonardo. Vasari recalled that among Leonardo's early models and architectural drawings, now all lost, was a proposal to raise the baptistery onto a polygonal base: "Among his models and plans there was one which Leonardo would often put before the citizens who were then governing Florence...showing how he proposed to raise and place steps under the church of San Giovanni without damaging the fabric. His arguments were so cogent that they would allow themselves to be convinced, although when they all went their several ways each of them would realize the impossibility of what Leonardo suggested."

Charismatic force of persuasion was often attributed to Leonardo, but his "cogent arguments" lay principally

A drawing based on Leonardo's proposal to raise the baptistery of Florence onto a plinth.

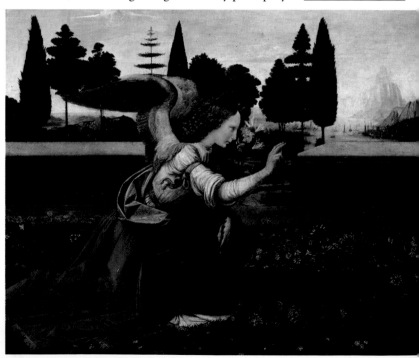

in the visual power of his drawings. Nevertheless, his project was not entirely untenable. In 1455, in Bologna, Aristotele Fioravanti had moved the campanile of Santa Maria del Tempio 42 feet 3 inches (13 meters).

## Leonardo's working methods

Two early paintings by Leonardo, made in Verrocchio's studio in collaboration with other students, are fundamental to an understanding of the artist's development. *The Annunciation* and *The Baptism of Christ* are perfect examples of the way art works were created in the workshops, from the setting of the iconographic program and the preliminary drawings to the first brushstrokes, the *pentimenti* and variants, and the assigned contributions of specialists.

Leonardo was among the first artists to use oil on panel instead of tempera, and significant discontinuities are

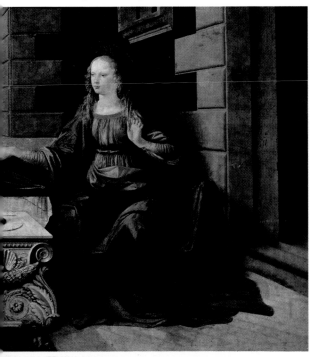

The quality of work in *The Annunciation* (left) varies, suggesting that it was created by more than one artist. The expressive gestures and plastic vigor of the protagonists' draperies are masterfully executed, with sculptural weight, while the flawed perspective of the Virgin's right arm indicates a less dextrous hand. Many details are striking and some are discordant: the angel's wings like those of a raptor; the meadow in flower, resembling a tapestry; the rigid solidity of the lectern decorations and the architectural elements; the scansion of the trees silhouetted against the light; the landscape organized rhetorically into three discrete sections. All these combine to create a scene as dramatic and formal as a theater set—one of extraordinary depth and spatial vastness, in which the threshold of the *hortus conclusus,* a low balustrade, divides the mystical event from its worldly surroundings. In the deep background, at the vanishing point of the work's precise and compelling perspective, lies a harbor scene lost in mists of light. This too introduces strident notes: towers and spires of fanciful architecture seem no taller than the nearby masts of ships. Inconsistent though it is, the painting is stunningly beautiful.

visible where he worked on a painting begun by others. *The Annunciation* (c. 1470–75), for example, reveals both the young man's limitations and his ambitions. It brings together innovative uses of pictorial space and plastic modeling, breaking boundaries and drawing on ideas from many sources, from the sculptural to the musical. Not all of these elements are Leonardo's; he played a determining role in this extraordinary composition, probably painted in collaboration with Ghirlandaio and other artists. The contributions of these diverse hands do not merge into a homogeneous whole.

When *The Annunciation* entered the Uffizi Gallery in Florence in 1867 it was attributed to Ghirlandaio. Leonardo's fellow students worked with him on both the first conception of the picture and the preliminary draft. The architecture on the right side of the painting was done by a zealous assistant and its style contrasts strongly with that of the heads of the angel and the Virgin, the clothing,

The attribution of *The Annunciation* principally to Leonardo is confirmed by the existence of preliminary studies by him of certain details, such as the angel's arm (below, left). Radiographic and spectrographic tests have revealed Leonardesque *pentimenti* in the angel's profile and hair, with its characteristic curls, and in Mary's head (left), where the *pentimento* covered a still earlier attempt.

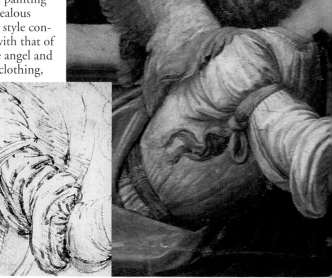

There are similarities between the form and decoration of the lectern at which the Virgin of *The Annunciation* sits and the architecture of the tomb of Piero and Giovanni de' Medici (above), which Verrocchio completed in 1472 for the Florentine church of San Lorenzo. The tomb of Carlo Marsuppini, made by Desiderio da Settignano in about 1453–54 for the church of Santa Croce, also has a similar ornamentation, based on classical Roman motifs.

and the landscape, all probably by Leonardo's hand.

*The Baptism of Christ,* painted between 1470 and 1476 for the church of San Salvi in Florence and mentioned in 1515 as by Verrocchio, is a good example of workshop production. Since 1510 tradition has attributed the angel on the left to Leonardo; Vasari relates that, faced with his student's superiority, Verrocchio "would never touch colors again, he was so ashamed that a boy understood their use better than he did." Other details are by Leonardo, including the landscape, which has elements in common with the autograph drawing of 5 August 1473, and with works by Leonardo's contemporary Antonio del Pollaiuolo (1431–98).

There are clearly at least two other collaborators: one who painted the figures and another, more modest artist who did the backgrounds. There are notable differences in style between the heads of the two angels, as well as in the treatment of the hands of the angel on the right, and a remarkable contrast in the landscape between the rigidity of the rocky outcrops and the fluidity of the streams and hills. The landscape has a symbolic value: geology's static

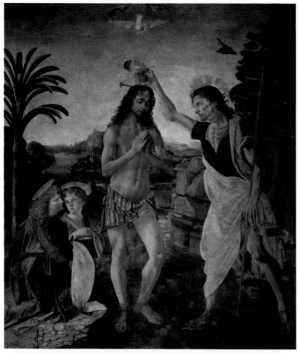

Verrocchio's *Baptism of Christ* (left) is thought to be partly by Leonardo, who is credited with the innovative contrast between Saint John's desiccated anatomy and Christ's muscular, elongated body and the pose of the leftmost angel, seen from behind, twisting sharply toward the ritual center of the scene. The attentive study of the refraction of light in the crystals that adorn this angel's robe (below, left) is surely Leonardo's, as are the sculptural effects of the draperies and the sublime, vertiginous landscape, inserted rather awkwardly into the scene.

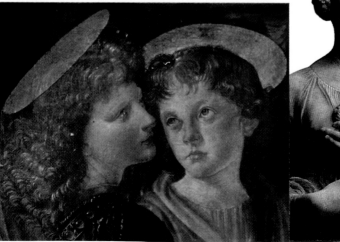

permanence is joined with water's regenerative flux in a cosmic synthesis.

## A symbolic portrait

The only portrait that Leonardo painted during his first Florentine period was that of Ginevra de' Benci, done in about 1474; she has been identified as the sitter from historical sources and by the symbolic presence of the juniper tree in the background (*ginepro* in Italian), which is repeated in a garland on the back of the painting. Ties of close friendship bound Leonardo and the Benci family, distinguished administrators of the Medici bank.

Technique, style, and conception all blend harmoniously in this small painting. Mixing tempera with oil, the artist has achieved a realistic likeness, expressed with spareness

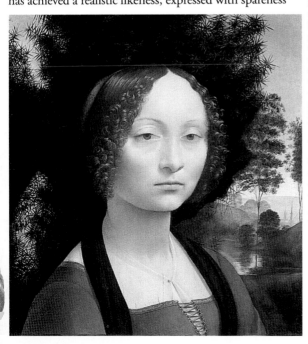

The Florentine lady Ginevra de' Benci (left), celebrated by the poet Cristoforo Landino for her "well-favored reputation," is here captured in an unidealized, natural pose. Her skin has a diaphanous luminescence, created with a few strokes of paint applied with the fingers; the fine veil around her shoulders echoes the delicacy of her features, as it does in Verrocchio's sculpture *Lady with a Bunch of Violets* (opposite). On the back of the painting a scroll (above) bears the epigram: "beauty adorns virtue." The sprig of juniper, referring to the sitter's name, is framed by sprays of laurel and palm, Christian symbols of chastity and virtue and classical symbols of art. Meticulously observed from nature, they express both the artist's tribute to his patron and his aesthetic program.

and a certain stillness. The hair is treated delicately and dynamically; its metallic brilliance is almost abstract and plays against a similar quality in the landscape, with its dark, evanescent silhouettes. All these unique features mark the work as by Leonardo, though it is unsigned.

## On trial for sodomy

Although Leonardo had belonged to the artists' guild, the Compagnia di San Luca, since 1472, and was therefore a professional independent painter, he continued to work

Leonardo's name appears (below, first line) in a 1472 document of the Compagnia di San Luca—"Lionardo di ser Piero da Vinci Dipintore," that is, Leonardo son of Piero, painter—and in the archives of his 1476 trial for sodomy (lower line). Bottom: *The Approach of Love,* a

+ LIONARDO·DS PIERO·DAVINCI·DIPI

Leonardo disspuro Junny for sandundlue

in Verrocchio's workshop in the following years. Two court documents of 1476 report (in Latin) that "Leonardo di ser Piero da Vinci manet cum Andrea del Verrocchio," that is, Leonardo di ser Piero da Vinci remains with Andrea del Verrocchio. These documents are from a trial for sodomy with a young man of seventeen; those implicated were Leonardo, a goldsmith, a doublet maker, and a certain Lionardo of the prominent Tornabuoni family, patrons of Verrocchio. The accusation had been made anonymously and was dismissed for lack of evidence. But the documents raise several questions: did Leonardo simply work with Verrocchio, or did he also live with him in via dell'Agnolo? And does this circumstantial accusation indicate that Leonardo was homosexual?

The year Leonardo was born Verrocchio had been tried in Florence for killing a woolworker with a stone, but despite this he became one of the most prominent artists in the city. Nor was he the only artist with an unsavory reputation: Perugino, Vasari reports, "like Leonardo in age and love affairs…would have fulfilled any evil contract for money." Giovanni Santi also described Leonardo and Perugino as "two adolescents, of the same age and fired by the same passions." Likewise, we know from court records that in 1479 one "Paulo de Leonardo de Vinci da Fiorenze" was banished from Florence for conducting "a bad life"; Giovanni Bentivoglio, lord of Bologna, wrote to

seduction scene sketched by the artist in about 1478–80.

Lorenzo de' Medici that after six months in jail the young man was distinguishing himself in the art of inlay. But we do not know if he was our Leonardo.

Later in life he had close friendships with handsome young men, often students. He never married, and two of these, Francesco Melzi and Giacomo, called Salai, were his heirs. To these scant facts may be added a few jottings made by Leonardo himself in his famous notebooks—anatomical observations, humorous comments—and a phallic doodle made by an assistant. Such vague references leave the question of the artist's sexuality open to conjecture, and one can scarcely draw serious conclusions, as scholars have sometimes tried to do, from a few fragments excerpted from thousands of sheets of manuscript.

## 1478: projects and coincidences

The year 1478 was a crucial one in Leonardo's life and work. At nearly twenty-six he received his first independent public commission (for an altarpiece that he never executed); and when political intrigues in Florence

L eonardo captions this allegorical drawing: "The unicorn, from intemperance and because it cannot restrain its taste for maidens...sleeps in their laps, and thus do the hunters capture them." Below: his sketches of an old and a youthful profile.

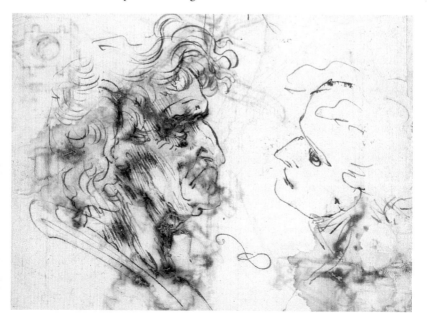

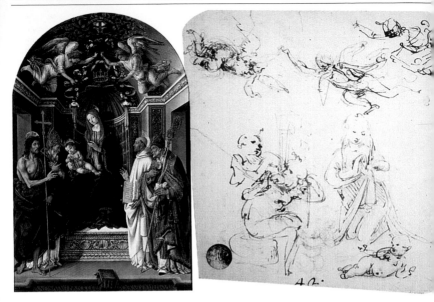

brought to power the statesman and banker Lorenzo de' Medici, called the Magnificent, his star rose too.

Leonardo's father had strong ties to the Medici, and Leonardo later worked on the restoration of Lorenzo's collection of antique marbles, housed in his garden. It was probably also in 1478 that he met the man who was later to become his Milanese patron: Ludovico Sforza, later duke of Milan, was then living in exile in Pisa and had come to Florence to pay his respects to the Magnificent. Gradually, in the course of that year, Leonardo left Verrocchio's studio to work on his own.

In Pistoia Verrocchio and his studio artists, Leonardo among them, worked on the great altarpiece of the *Madonna della Piazza,* begun some three years earlier, as well as a sculptural tomb monument for Cardinal Niccolò Forteguerri. Independently, Leonardo began to work on two paintings that he refers to as "the two Madonnas," one of which may be the *Benois Madonna.* Sketch details of these appear on the same notebook pages as drawings of military and construction machines, other mechanical systems, and two profiles, one in the classical style, the other related to Leonardo's studies for an *Adoration of the Magi.*

The dynamic posture of the child in Filippino Lippi's altarpiece for the chapel of San Bernardo (above, left) recalls Leonardo's drawings of babies in active poses, while the angels resemble some of his drawings (above and opposite, above). These in turn are related to an angel relief that Verrocchio executed for the Forteguerri tomb in Pistoia (opposite, below).

On 10 January Leonardo was given the commission for the altarpiece for the chapel of San Bernardo in the Palazzo della Signoria, the town hall of Florence. It has been suggested that he received this and other commissions

After 1478 Leonardo's studies for *Adorations* and *Madonnas* multiply in an astonishing series of drawings, wide-ranging and constantly experimental in point of view, conception, and approach. Through these he redefines the iconography of the key subjects of Christian art in humanistic terms. His sources for the great biblical figures come from observed nature, not the established traditions of iconology. Drawn directly from life, these images transform mundane reality through the grace, immediacy, and freedom of their execution.

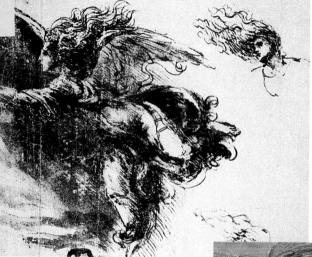

through the offices of his father, influential notary of the Signoria (the city council), but Leonardo was himself close to several important Florentine families. He began the altarpiece, but soon gave it up; after he left for Milan in 1482 it was taken up by Ghirlandaio and finally completed in 1485 by Filippino Lippi (c. 1457–1504), apparently following a cartoon by Leonardo.

There is, in fact, little verified information about Leonardo's design for this altarpiece, though we know that he made a number of studies for a *Nativity* and an *Adoration* at this time, as well as series of variations on the theme of the *Virgin and Child*. In the course of these he passed once and for all from a

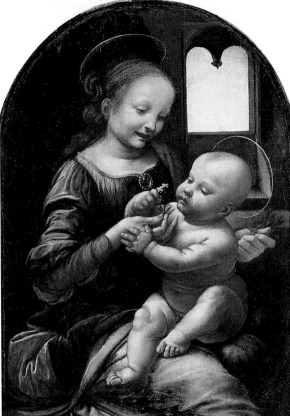

The *Benois Madonna* (left) is a work of refined intimacy, informed by great tenderness and an acute sense of the psychological moment. Note the subtle variations in light, the dynamism of the billowing fabric, the rotating diagonals of the composition, and the focal points that cross in the three-dimensional space.

workshop approach to a radically new and personal one, based on an exploration of the real.

## Drawing in the round

The idea of "cinematic" drawing—that is, drawing from multiple, sequential viewpoints—was a constant in Leonardo's research. He was fascinated by three-dimensional representation and by the idea of variations on a theme. His gaze moved around a subject, rose above it, drew nearer, examined its other side. From his youth he filled pages with drawings for *Virgins* and *Adorations*—pages covered, with obvious pleasure and

enthusiasm, with scores of studies of hands, female torsos, and children's limbs seen in every possible position and from every possible angle. He made myriad studies of horses and cats in motion, aspects of human anatomy, architecture, and machinery in use. In a series of drawings of *Leda and the Swan* Leda is at first seen kneeling; sketch by sketch she comes to stand beside the swan. Some drawings show the same figure in different positions, usually frontally, laterally, and from the back. Over time he developed a vast repertory of such active poses and

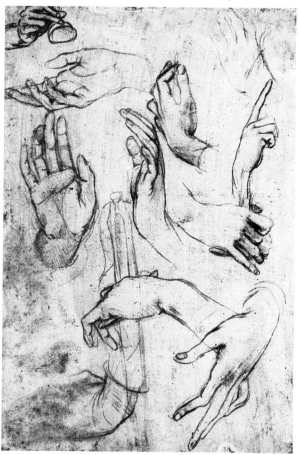

In 1478 Leonardo referred to two paintings of the Virgin Mary, one of which may be the extant *Benois Madonna* (opposite, far left). The *Madonna with a Carnation* (page 27) is a candidate for the second, though its style is very different; another possibility is the lost *Madonna with a Cat*, known only through studies (opposite, right). In such highly allegorical pictures even the natural elements and minor decorative details have symbolic significance. Leonardo follows a long tradition in his intimate representations of mother and child together. In the *Benois Madonna* (also called the *Madonna with a Flower*) certain details, especially in the faces, were altered when the painting was transferred from its original panel to canvas. Though the work was once attributed to Verrocchio and to Lorenzo di Credi, Leonardo's hand is recognizable in the expressive freshness of the scene, the lively animation of the composition, the rhythmic use of space and light, the vigor of the draperies, the treatment of the hands, and the articulation of anatomical form. Left: a series of studies for hands for *Annunciations* and *Adorations*.

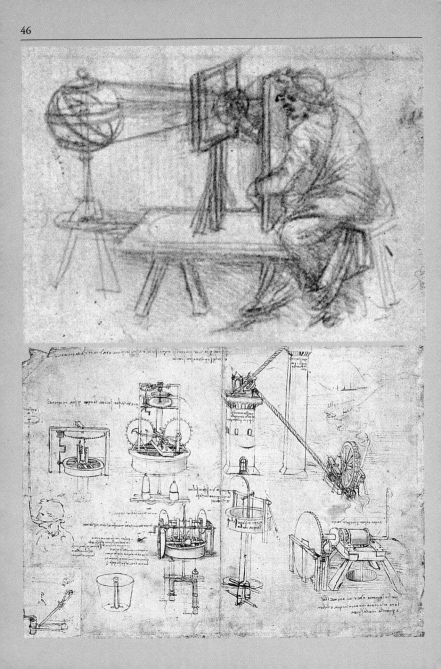

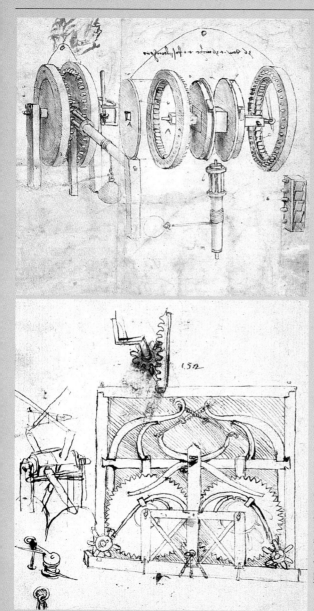

Leonardo's earliest collected drawings include some datable to 1475. These confirm that from the beginning he was interested in engineering as well as painting. Among these drawings are a perspectograph (opposite, above), systems of hydraulics and mechanisms for breathing under water (opposite, below), a projector (above), and a self-propelling cart, famous as "Leonardo's automobile" (below, near left). In his researches he reviewed ancient and medieval sources and the writings of Tuscan engineers of the early 15th century. He tended to invent increasingly complex mechanisms—true machines based on simple, traditional devices such as the winch, pulley, lever, wedge, and screw. He deconstructed his designs (above, near left: the parts of a motor) in order to depict them in variant forms, always showing a great concern for their aesthetics, as well as for their practical purposes.

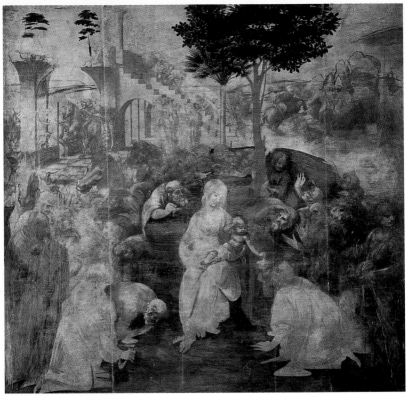

gestures, many of which he later used in *The Last Supper*. In his *Treatise on Painting* he addressed this idea of multiple points of view in sculpture and drawing by making an analogy to the way a ceramic vase is thrown on a wheel, constantly displaying infinite aspects in its rotation.

## To draw with painting

Leonardo ended his first Florentine period with a veritable manifesto of humanism. The unfinished *Adoration of the Magi* was the first painting that he conceived in his radically individual—indeed, revolutionary—way, as a grand display of intricate iconography. The painting has a profound meditative quality, tinged with pathos. In it the rational meets the irrational and a deep awareness of

Spectrographic (X-ray) analysis of *The Adoration of the Magi* has revealed significant new information about this painting, including the identification of one of the figures on the right as a portrait of the poet Dante. The figure at far right bears a certain facial resemblance to Verrocchio's *David* and has sometimes been proposed as Leonardo's self-portrait.

history is wedded to a sense of rebirth. Its layers of backgrounds open onto vast perspectives of faraway horizons; the foreground figures display a complex repertory of psychological attitudes, relationships, and symbols.

The gears, screws, and springs of this pictorial machine are figures, gestures, poses, geometries, states of mind, attitudes, and emotions. At the apex of the pyramid formed by the Virgin and the kneeling Magi is the Child, the center of this cosmogony. All around the infant kings, shepherds, angels, and horsemen are in motion within the vast, enveloping movement of the epiphany—more revelation than mere adoration—that is the true motive force of the composition. Fluid, almost sculptural drawing technique, rich chiaroscuro, and integrated dynamics confer great intensity upon the scene. Later alterations to the panel's surface make the picture difficult to read, but radiographic analyses have revealed many hidden details.

The monastery of San Donato in Scopeto, of which Piero da Vinci was notary, commissioned *The Adoration of the Magi* in March 1481. Leonardo contracted to complete the picture in less than thirty months, but it remained unfinished, as did his *Saint Jerome,* when he went to Milan to seek new patrons at the end of that year. Did this work represent the highest degree of development his painting had reached in 1482?

L eft: a study for two figures in *The Adoration of the Magi.* Below: *Saint Jerome* was at one time in the collection of Napoleon's uncle, who is supposed to have bought it in a junk store, where it had been made into the cover of a chest. The painting was missing the saint's head, found some months later in the shop of a cobbler who was using it as a table. It is stylistically similar to *The Adoration of the Magi,* with fine attention to anatomy, an almost sculptural domination of space by the figure, and a familiar unfinished quality.

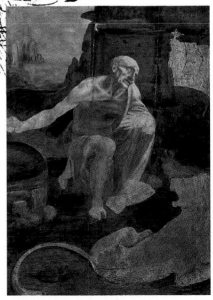

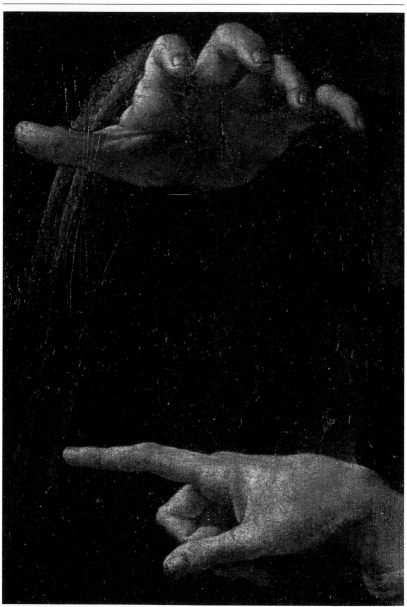

The painter presented himself to Ludovico il Moro, regent of the duchy of Milan, as an expert in the military arts and offered him his secrets: "bridges [and] covered ways…methods of destroying any citadel or fortress…secret underground tunnels…covered vehicles, safe and unassailable…bombards, mortars [and] other unusual machines of marvelous efficiency…an infinite variety of machines…. Moreover, the bronze horse could be made that will be to the immortal glory…of the illustrious house of Sforza."

CHAPTER 3

# IN MILAN IN THE TIME OF THE SFORZA

Leonardo's first painting in Milan was *The Virgin of the Rocks* (page 55). Opposite: a detail of Mary's hand, hovering in a ritual gesture, as if in an exercise in levitation, over that of the angel, with pointing finger. Right: a page from a manuscript in the *Codex Atlanticus* on which Leonardo drew Milan's principal landmarks.

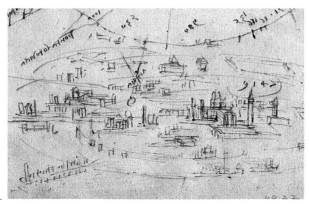

In 1482 Leonardo left Florence for Milan. Officially, his purpose was to take a gift to the regent, Ludovico Sforza, called il Moro (the Moor, for his dark coloring), from Lorenzo the Magnificent: a silver lyre, a precious musical instrument in the shape of a horse's skull. He himself had a reputation as a fine musician. At thirty he was now an official ambassador of the arts serving the strategy of Lorenzo, who promoted the cultural prestige of Medici Florence in order to advance his political and economic relationships. But there were other reasons for Leonardo

*Below: a passage from Leonardo's letter (not in his hand) to Ludovico il Moro. All the projects he proposed are sketched out in his notebooks. He explored ideas for an armored car and (bottom) an assault vehicle with scythes; similar carts were already in use, but Leonardo*

*[handwritten passage in Italian, not transcribed]*

to leave Tuscany, and he was very concerned as he made his way north to Milan to seek his fortune.

## Milan, the Athens of Italy

In 1481 Pope Sixtus IV had invited a group of the best Florentine painters to come to Rome to work at the Vatican: Botticelli, Perugino, Piero di Cosimo, Ghirlandaio—but not Leonardo. We do not know why he was overlooked, but the artist's notes from the period manifest a certain pessimism. The Florentine climate of humanism, which was essentially Neoplatonic, frustrated his ambitions; he hoped to find in Aristotelian, pragmatic Lombardy an environment more supportive of his experiments.

The duchy of Milan was wealthy, modern, and industrious; in a divided Italy this drew the covetous eyes of other European states. Its cultural traditions differed somewhat from those of Florence; an aristocratic court rather than a republic, it mingled the legacy of the northern International Gothic style with Renaissance innovation. Milan numbered few outstanding practitioners of the figurative arts, but Ludovico il Moro (1452–1508) meant to make his capital city the Athens of Italy, to create

*elaborated ways to use them tactically in battle. He recommended that riders advance shouting loudly, in order to panic the enemy's horses. He noted that such vehicles "often did no less injury to friends than they did to foes." His extraordinarily dynamic drawings clearly illustrate the effect of these war machines by showing the mutilated soldiers they have mown down.*

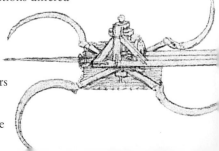

a Parnassus that would rival Florence itself, as well as the neighboring city-states of Mantua, Ferrara, and Urbino. He intended the Sforza line to rival the dynasties of the Medici, Gonzaga, Este, and Montefeltro families.

As a courtier Leonardo hoped to receive a salary as well as payment for each work completed. That would enable him to pursue the experiments that increasingly intrigued him, even if it meant fulfilling the time-consuming function of master of ceremonies and ornament of Ludovico's court. He therefore composed a ten-point letter addressed to the lord of Milan, asking for a post.

In 1482 Milan was allied with Ferrara in a war with Venice. Milan's fortune was based on military rather than mercantile achievements and the military arts played a crucial role in its economy, as did the manufacture and sale of arms. This explains the emphasis of Leonardo's letter. In the first nine points he stressed his talents as a military engineer, proposing to execute in peacetime works of architecture and hydraulics, as well as paintings and sculpture. Finally, he urged the creation of a bronze equestrian monument in honor of Francesco Sforza, Ludovico's father. In addition to his art, with which the regent was acquainted, Leonardo offered a rare inducement: his inventions and practical knowledge, his engineering feats, and his dream machines.

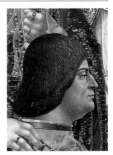

Above: one of the best-known portraits of Ludovico Sforza, a detail of the *Pala Sforzesca,* an altarpiece by an unknown artist of Leonardo's circle. Leonardo wrote several allegories about Ludovico, among them this gnomic phrase: "Il Moro with the spectacles and Envy represented with lying Slander, and Justice black for Il Moro." The glasses symbolized "better understanding."

### Enigmas and harmonies

We do not know whether Leonardo sent the letter to Ludovico or not, though the surviving document is a copy. He did not, in any case, obtain immediate employment at court, and so found it necessary to establish himself as an independent artist and inventor while he pursued his higher ambitions. It is very likely that he went to Milan in the company of a musician, Atalante Migliorotti. Legend has it that Leonardo himself played the lyre and was a skillful interpreter and master of music. Later, he invented instruments and fantastic theatricals that were the wonder of the courts of Milan and France. His notebooks contain studies for mechanical drums and wind instruments with keyboards, an organ-viol and a portable organ, a flute and a bagpipe, and even automatons and hydraulic machinery to create sound effects for the theater. There are no complete musical compositions known to be by Leonardo; more often than not his musical notations comprise clever riddles and rebuses.

One of Leonardo's great themes was harmony, the harmony produced by music and by the sound of water, but also harmony as aesthetic study and equilibrium among elements, harmony in the measurement of time and as a cosmological principle. If, for him, painting was a "divine science," music must be its sister. Nevertheless, he wrote in the *Paragone,* a part of his *Treatise on Painting,* "Painting is more important than music and dominates it, for it never dies once created, unlike unfortunate music." He privileged the eye, "the window of the soul," and valued sight over the other senses. Leonardo's thought was a constant web of counterpoints and analogies. For him, music was a cerebral science, a refined art,

Left: a fanciful drawing of an animal-head lyre. Below: two of Leonardo's rebuses in mirror writing. Leonardo used the musical notes of solfeggio to compose the upper one: *La mo re mi fa so la za re* (*L'amore mi fa solazzare,* or "Love gives me pleasure"). The lower one reads: *Pero se la fortuna mi fa felice tal viso asponero* ("But if Fortune smiles upon me, then I will change face"). Leonardo loved visual puns and rebuses: for example, *pero* in Italian means both "but" and "pear tree"; hence the drawing above each word.

artificial but also primordial, which he sometimes described in strange little riddles: "The wind that, passing through the skins of animals, makes all men jump" is "the bagpipe that causes people to dance," the music of a

There are two versions of *The Virgin of the Rocks:* the one in Paris, dating to between 1483 and about 1485 (far left),

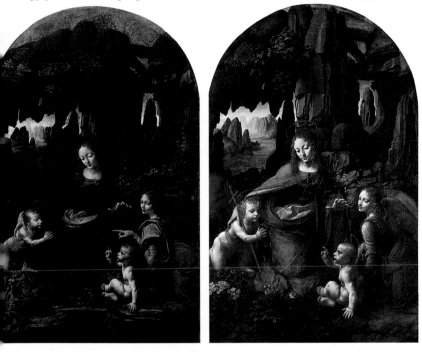

primitive, atavistic world. Above all, however, music would always be "the representation of invisible things."

## Painting, too, became "the representation of invisible things"

The first work by Leonardo known to have been executed in Milan is the immensely complex *Virgin of the Rocks.* A metaphysical painting, it is a paradigm of aesthetic concepts that Leonardo had intuited but not fully expressed in the Florentine period, in his unfinished *Adoration.* It was to become the prototype of a manner or style adopted by Leonardo's followers. To plunge a scene of high religious allegory into shadow was a novelty; the

is unarguably autograph, while the London version of 1493–1508 (near left), though disputed and much retouched, is at least largely so. The Paris *Virgin of the Rocks* is bathed in a vibrant crepuscular atmosphere; a secret magic seems to emanate from the shadows. The brushstrokes are more fluid in the London version, resembling petals of color.

effect is to give those elements that thrust into the light the power of revelation. Figures, haloes, and reflections of secondary lights have the appearance of spiritual emanations.

For twenty-five years *The Virgin of the Rocks* was at the center of a dispute between Leonardo and his clients, the Confraternity of the Immaculate Conception at the church of San Francesco Grande in Milan. Despite the discovery of new archival documents, the painting still presents a mystery. Leonardo painted two versions of it, one now in Paris, the other, begun much later, now in London. The first version was the object of many disagreements and a lengthy lawsuit; it appears to have dissatisfied its patrons. When Leonardo accepted the commission on 25 April 1483 he undertook to paint the work in a little over seven months, but he seems to have completed it only around 1485 or 1486. Then, sometime around 1493, it seems, he painted a second version, returning to it and finishing it between 1506 and 1508 and obtaining permission to make further copies at that time. He signed a certificate of completion for this second version on 23 October 1508.

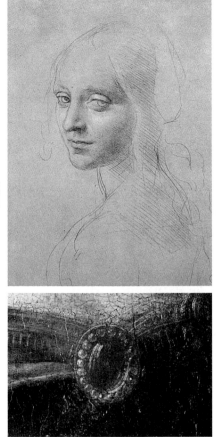

Top: the art historian Bernard Berenson considered this study for the Paris *Virgin of the Rocks* "one of the finest achievements of all draughtsmanship." Above: the brooch at the center of the Paris painting does not appear in the London version.

The painting represents an extraordinary synthesis of Leonardo's major iconographic themes and art theories. It is replete with hermetic signs, secrets, and allusions that lend themselves to myriad symbolic and theological interpretations. The damp, flower-strewn cave is a dark space within the body of the earth, both womb and cavern of knowledge, haloed with a metaphysical and esoteric aura that is tinged with mystical lyricism and mystery. The rocky recess and the inaccessible mountains that recede

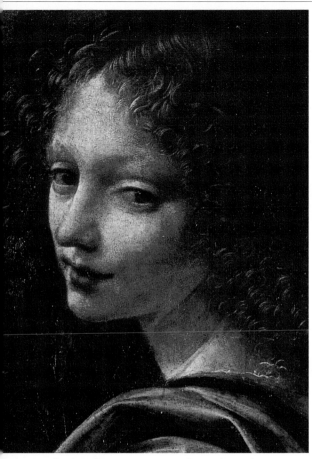

In the Paris *Virgin of the Rocks* the angel looks out of the picture frame, past the spectator, and into a zone we cannot see. Some have considered this figure ambiguous, even demonic, with its almost clawed right foot. The London version maintains the pyramidal composition of the original, in which intersecting lines between the four figures form a cross, but in the later painting the four are more powerfully present in space. Each element is bathed in light and has its own visual and spatial dynamic, especially the Virgin's yellow drapery. In the Paris version the drapery comes across as an abstract notation, while in the London painting it looks more concrete. The religious theme is treated differently as well: in the Paris painting the flowers chiefly symbolize the Passion, while in the London painting they are emblems of purity and Marian humility. Giacomo del Maiano's splendid gilt-wood frame for the first version has vanished, though the lateral panels survive (attributed to Ambrogio de Predis or Marco d'Oggiono); these represent two simple music-making angels, rather than the eight musicians and singers originally planned.

into a glowing distance represent the geological, primordial world, the cryptic theater of the holy, purely spiritual event: the meeting of the infant Jesus and the child John the Baptist in the wilderness. In this charged, arcane space the gestures of children, mother, and attending angel remain suspended and touched with light, as if to capture the instant in which Christian history began. This iconography does not match that specified in the contract of 1483—the Virgin and Child between two angels and two prophets, without Saint

John; Leonardo's highly personal alterations provoked speculation about heretical intentions.

The Virgin's brooch is an extraordinary key to the painting's morphogenesis. It constitutes a kind of microcosm, an eye of refracted light and deep shadow, like a dark mirror. The Virgin's face is at the point of convergence of several diagonals, but the brooch, with its twenty pearls and glassy cabochon, is at the precise center of the composition.

## Leonardo's first Milanese workshop

Leonardo may have wished to be an engineer by appointment to the court, but in Milan he first became a well-

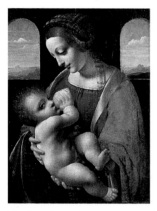

known and successful *depinctore* (painter). He founded a workshop, complete with collaborators and pupils, including Ambrogio de Predis (c. 1455–c. 1522); Giovanni Antonio Boltraffio (1467–1516); Giacomo, called Salai (born 1480), whom he raised in his home; Marco d'Oggiono (c. 1470– c. 1530); Francesco Galli, known as Napoletano (died early 16th century); and an unknown German mechanic, Giulio Tedesco. His studio produced fine paintings noted for a unified conception, elegant technique, and sensitive use of *sfumato,* Leonardo's soft, rich, smoky shadowing. Among these is the *Madonna Litta,* also called *The Virgin of the Milk.* Though remarkable for its foreshortened composition and its use of vivid symbols (the nursing Mary, or *Virgo lactans,* most ancient of Christian images, and the goldfinch, which dwells among thorns and is an emblem of the Passion), this painting is no longer attributed to the master himself. The painting can be dated to 1485–87 or later and has certain details in common with the London *Virgin of the Rocks.* Was there an original version by Leonardo? The idea is certainly his.

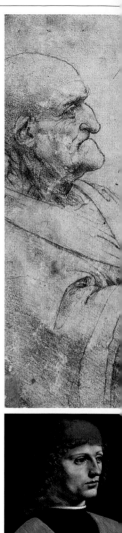

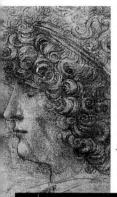

## The return to portraiture

Two panels from the years 1485–90, *The Musician* and *Lady with an Ermine,* illustrate the profound revitalization that Leonardo brought to the portrait genre. *The Musician* is a veritable concert of references to earlier works, from *Ginevra de' Benci*'s glowing curls to *Saint Jerome*'s sculptural anatomy. But in it Leonardo attains an unprecedented level of psychological intensity,

*The Old Man and the Youth* (above, center) is characteristic of Leonardo's studies of faces—ideal and grotesque profiles—and physiognomic contrasts. For almost three hundred years *The Musician* (opposite, below) was believed to be a portrait of the ruler of Milan, until the musical notes on the paper were recognized, revealing that a still-unidentified musician is portrayed. *Lady with an Ermine* (left) probably depicts Cecilia Gallerani (in Greek, "ermine" is *galē*), who became Ludovico il Moro's mistress in 1490, when she was seventeen years old. Later retouchings obscured the luminous range of colors of the background, introduced an inscription with a mistaken title and a *W* for Vinci, and changed her hair. They altered the geometry of her dress's tracery, the necklace, the shape of her left hand, and the third and fourth fingers of her right hand—yet the skill and elegance of this masterpiece endure. By comparison, the *Madonna Litta* (opposite, far left), a product of Leonardo's workshop, lacks the vitality of the autograph works.

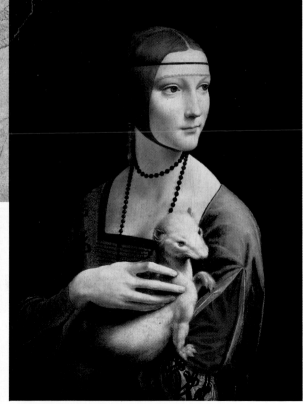

which reaches the sublime in *Lady with an Ermine*. Notable are the work's determinedly Lombard quality, the influences from Northern Renaissance style, and the portrait's dynamism, which suggests that brief moment in a musical interlude when the singer holds both gesture and breath. It is almost certain that Leonardo collaborated on the work. The preparation and technique are his; an assistant such as de Predis may have participated marginally in the execution.

There is no reliable information about *Lady with an Ermine* before the late 1700s, when it entered the Czartoryski collection in Poland from Italy. Attribution to Leonardo is, however, almost unanimously accepted, given the refined presentation, the use of light and smoky shadow, the contemplative tone. Despite restorations, the portrait is even more fascinating to the acute observer than the famously enigmatic *Mona Lisa*. The rhythm of the composition and the movement of the figure, which twists in space along a spiral that diverges from that of the pet in her arms, are absolute innovations in the art of portraiture. The sitter has been tentatively identified as Cecilia Gallerani, mistress of Ludovico il Moro, suggesting that Leonardo had by the mid-1480s been granted court commissions.

L eonardo captioned this sketch (right) of an abstract mechanical element, which seems to have a serpentine life of its own, with an autobiographical note: "Body formed from the perspective by Leonardo Vinci, disciple of experience. This body may be made without the example of any other body but merely with plain lines." Here his inventiveness reaches the pure artifice of art, based on no imitation of nature but only the artist's own imagination competing with that of "the divine creator."

### An uneducated man, an artist of science

Five years after his arrival in Milan Leonardo felt the need to organize, gather, and systematize all his theoretical, practical, artistic, and technological knowledge. He collected jottings of all kinds into notebooks of various sizes and began to plan a series of treatises. Thus began his transformation from an artist of machines to an artist of science.

The first problem he faced was his limited education, which gave him

A sketch of a face appears amid columns of words in a page of the *Codex Trivulzianus* manuscript (opposite). Leonardo was equally enthused about human flight and the mythic attempts at it, from ancient Chinese kites to those of the Veneto writer Giovanni Fontana, who converted them for military signaling, to Giovan Battista Danti's legendary experiments on Lake Trasimene. Leonardo also planned to fly over the lakes of Lombardy. He designed a parachute (below) of entirely plausible proportions, intended to reduce the risk of injury from falling while flying in a machine.

little access to classical sources. He described himself, with the spleen often characteristic of his private notes, as "unlettered…an uncultured man," who learned what he knew from experimentation and practice. He decried as "*gente stolta*"—stupid fools—those presumptuous and arrogant academics who used his self-education as an excuse to criticize him blindly and unfairly. The violent moods of which he left traces in his personal notes reveal two fundamental aspects of his personality: he was not only aware but proud of not having received a bookish, rhetorical education; and he had faith in the universal values of art and in the creative power of his direct knowledge of nature. Leonardo took pleasure in presenting himself as a self-made man; he rejected the cultural hierarchies established by the classical tradition—the distinction between the liberal and the mechanical or "servile" arts and the valuing of erudition above experience. Yet he recognized that "science is the captain, practice is the soldier" and "those who fall in love with practice without science are like a sailor…without a helm or compass." Let us not forget, however, that for Leonardo, painting was a science as well.

If Leonardo was often a practical man in search of a theory, he nonetheless remained the consummate artist, one who desired always to extend himself in search of elusive goals. He nourished the great dream of art, imagining it as a utopia. Both artist and artisan, he envisioned imaginary technological, mechanical, and architectural creatures and then set about designing them in concrete terms.

## The art of flight and submarine dreams

The myth of Icarus fascinated Leonardo, who explored the art of flight in the pages of at least nine notebooks at

"The screw creates a helix in the air and rises rapidly." This famous precursor of the helicopter (left) is believed to be derived from a child's toy, a paper windmill. Below: a diving bell for breathing under water.

different times in his life. In Florence between 1487 and 1490 he drew fabulous flying machines that flapped like birds' wings. Soon he began to apply notions of mechanics, physics, and anatomy to the idea of flight, drawing parachutes and whirligigs. He studied aerodynamics in order to understand wind currents, wind resistance, and problems of centers of gravity; he examined in detail the action of a bird in flight, analyzing it as "an instrument functioning according to mathematical laws"; observing kites and other birds of prey in flight, he concluded that "the bat is the only model."

To Leonardo, flight was the acme of mechanical engineering, the ultimate design project of the Divine Engineer. He imagined human flight as both a practical possibility and a metaphysical idea: to dream of flight was to contemplate immensity, to test the solemn geographies of human limits.

Corresponding to the conquest of the skies was the dream of traveling under water and walking on its surface. But if the impetus to create a flying machine represented an aspiration toward ultimate liberty, the inspiration to invent subaqueous vessels seems, for Leonardo, to have been chiefly military. Next to some studies of what may be a submarine of some sort is this note: "a boat to use to sink ships

with the instrument that you know of." What was this tool? Leonardo intended to keep his naval invention secret until he had a "contract for the instrument" signed in the presence of a notary. He seems to have believed that it would make him rich. He drew several tools for attacking ships below the water line: a series of corkscrews meant to pierce the hull and a device for pulling planks out of it. Other sketches include a diving suit of remarkable, if not very functional, design; a sophisticated diving bell; an underwater breathing apparatus; and a pair of shoes, rather like snowshoes, for walking on water.

## Bestial folly

Leonardo called war a "*pazzia bestialissima,*" a most bestial folly, but like other thinkers of the Renaissance he also saw it as a necessity. He maintained his repugnance for weapons used treacherously or for assassinations, such as poisoned arrows, but designed many ingenious and

Leonardo designed a machine twenty spans wide (100 feet, or 32 meters; opposite, lower left) that would fly from a mountaintop, supported by the wind: "Man when flying must stand free from the waist upwards so as to be able to balance himself...so that the center of gravity in himself and in the machine may counterbalance each other." Giant multiple crossbows in a revolving rack are one of his imaginary weapons; he also used a crossbow mechanism in selfpropelled carts, clocks, and flying machines.

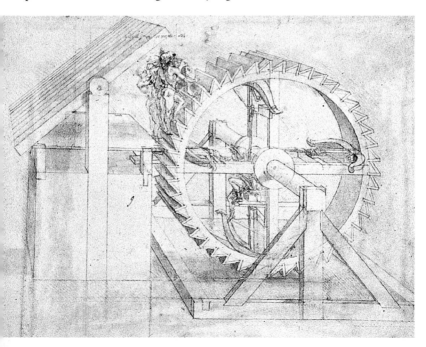

Like most Renaissance rulers Ludovico il Moro had a number of emblems, such as the mulberry (*moro*), which he placed as decoration everywhere he could and to which he assigned allegorical meanings. Leonardo, whose intellect and taste were pure Renaissance, also loved allegories, allusions, and secret or ironic symbolisms. He wrote fables and drew pictures depicting the opposition of contrary things; defending prudence, beauty, and truth against life's snares and vices; and expressing his resentment of envy, treachery, and calumny. Opposite, above: Phyllis riding Aristotle, a medieval parable of sex conquering wisdom; below: an allegorical scene worthy of the modern metaphysical painter Giorgio De Chirico blends solar energy, a mirror, a unicorn, and other fantastic animals. This page, above: man rises by means of a tree's branches, supported by the buttress of geometry; below: at left Envy rides Death; at right Virtue, holding an olive branch, triumphs over Envy (with a scorpion's tail).

deadly devices himself, offering them to the warlords who were his patrons. His drawings of battle and its tools number in the hundreds; they are powerfully evocative, beautiful, and sometimes quite theatrical. A drawing (see page 142) in the *Codex Atlanticus,* a collection of manuscripts, shows a bombard (a sort of mortar launcher, which he called "the most lethal machine that it is possible to make") sending a barrage of exploding projectiles across the page like a shower of pyrotechnic stars.

## The physician-architect

Leonardo was equally avant-garde in the fields of architecture and urban planning, though he was no rebel against the political status quo or his noble patrons. He was always looking for commissions and trying to invent and seize opportunities, however limited they often proved to be. He designed numerous villas and other buildings, but though some were evidently built, no extant edifice can be attributed to him with certainty. His notebooks contain studies of every sort of structure: stables and temples, houses, arcades, churches, and impregnable citadels.

The drawing for the *tiburio,* or lantern tower of the Milan cathedral (left), is a remarkable example of architecture as anatomy—in this instance, a skeleton or framework. Similarly, the skull in section (lower left) may be compared with the drawing of an apse (opposite, lower right).

In 1487 a wooden model for the lantern tower of the Milan cathedral was made from a plan by Leonardo. The problem that he solved was that of covering the crossing of a vast and much older church, Gothic in style and long unfinished. He saw architecture as a living organism: if a building is sick, he remarked, it needs a "physician-architect." His solution was an innovative medley of traditional ideas, abstract geometrical concepts, and engineering principles. The metaphor of a building as an organic body was not new, but Leonardo's expression of it, inspired by Plato's *Timaeus* and Ptolemy's *Cosmography*, linked it to a larger conception in which the human form or the form of a building is related to the forms and structure of the universe, as microcosm to macrocosm. He made analogies between architectural and human anatomies (e.g., the skull as a cupola) and referred to these formal relationships as diagrams of musical harmonies. The drawings of buildings and architectural elements in the treatises of the contemporary Sienese theorist Francesco di Giorgio (1439–1502) were similarly based on the proportions of the human body. From the measurements of a column to the section of a church, this concept recurs in Leonardo's architectural sketches, in particular the famous drawing of man's proportions, datable to about 1490, which refers directly to the ancient Roman architectural canons of Vitruvius (1st century BC). In this picture the human body is inscribed within a circle, the geometric absolute; its midpoint is the navel, the *omphalos* of the ancient Greeks, the center of the universe.

## The city beautiful

In 1484–85 Milan was struck by plague; its aftermath saw a renewed interest in the idea of city planning and sanitation. Leonardo, by now almost certainly in favor at Ludovico's court, conceived of an ideal New City based on rational principles of order, natural dynamics, symbolism, and functionality. His urban structure was carefully arranged and thought out, from the dwellings of nobles to the sewer

I n this study (left) Leonardo synthesizes the disparate architectonic concepts of Vitruvius and Francesco di Giorgio: harmony and human proportion are the ideal principles of architecture.

O verleaf, top: his ambitious urban-renewal project for Milan foreshadowed the multi-level satellite cities, with their imitation of organic structures, that futurists have imagined in the 20th century. He dreamed of a utopian urbanism that would unite the arts and sciences.

system. Roads and waterworks were designed for optimal hygiene and efficiency of circulation. His city was organized less by class hierarchies than by the individual function of its parts; as in the study of anatomy, he identified its distinct systems, beginning with the infrastructure.

It is not surprising that Leonardo's ideas on urbanism were not adopted by the regent of Milan; indeed, we only know them through fragments that are closer to futuristic visions than to the Renaissance tradition of utopian city planning. Nevertheless, in 1493 he designed a pilot project for the rebuilding and expansion of Milan, elements of which were used. He was by now an expert in hydraulics and water systems and studied the *navigli,* the city's canals. As he developed his urban plan he devised ecological metaphors for this new subject of study, such as the fable of the country stone that fell ill when it came to the unhealthy city. "Thus it happens," the moral runs, "to those who choose to leave a life of solitary contemplation, and come to live in cities among people full of infinite evil."

In the 1490s Leonardo, Donato Bramante (1444–1514), and Giovanni Giacomo Dolcebuono (1440–1506) were the most respected architects and engineers at the Sforza

B̲elow: a stairway with two ramps that diverge and then converge. Bottom: a central-plan church; such circular forms refer to a womb or navel. Opposite: on a single sheet are studies for a fortress, a garden gazebo, and a labyrinth, as well as for a simple tile roof.

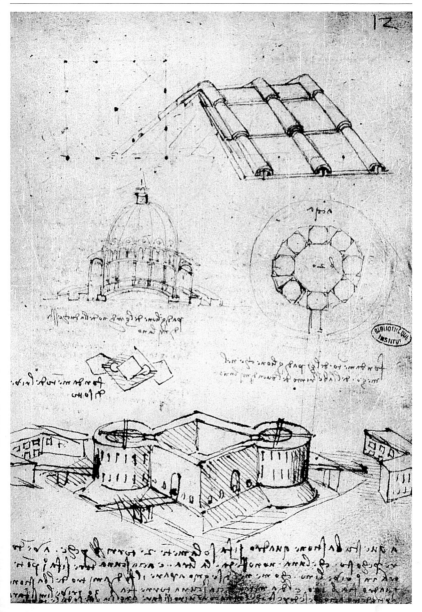

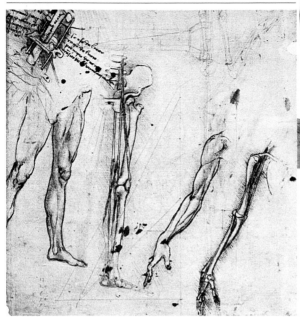

Left: a study of human bones and tendons and of the spinal marrow of a frog (upper left corner) dissected by Leonardo. His notes, in both normal and mirror writing, describe a vivisection experiment he had conducted. He wrote that the *virtù gienitiva,* the life-giving property or seminal fluid, must be located in the marrow. This accorded with an ancient theory. Above: one of the earliest students of physiognomy, he made beautiful drawings of deformed faces in order to characterize the "ugly."

court. Il Moro was now renovating the ducal seat at Vigevano, his birthplace, as well as sites in nearby Pavia and Milan. Leonardo had a hand in many of these projects. The ancient science of hydraulics was remarkably advanced, especially in Lombardy, and was already being used in irrigation and land drainage, as a source of power, and in the regulation of waterways with locks and canals. Leonardo investigated all of these, traveling as far as Piedmont, near France.

## "The book entitled *On the Human Figure*"

At this time Leonardo was pursuing his studies of anatomy, seeking to understand not only how the body functions but also its very essence. In more than one book he explored the "motions" of the soul in human gestures and what he called the five categories: mental, temporal, vital, sensory, and "of the kind of things." Using Aristotelian terms, he sought "the origin of the first and perhaps the second cause," wishing to reveal the

secrets of the human body. From this arose his next innovation: the idea of anatomy as an art—of anatomical drawing as relating both to aesthetics and to scientific observation. His first studies from life followed accepted notions of anatomy, some of them wrong. He was drawing not only what he saw, but what he expected to see. And as the law prohibited human dissections, though he apparently performed some, he was often obliged to visualize the human body through animal dissections.

He set out to discover the physical location of the soul. He intended to prove that it "is not all of it in the whole body as many have believed," but must lie at the center of the brain, for "judgment apparently resides in the place where all the senses meet" and where imagination, intellect, and common sense live. Using a startling hierarchical military metaphor, he defined the soul as a prince who is served in the central ventricle of the heart by a captain of sensory perceptions (that is, common sense); the "nerves with their muscles" are soldiers who serve knights. In the spinal marrow the animal spirits transmit sensations along the lateral canals, while the "generative power" does the same through the central canal. Leonardo pursued these matters for many years; his anatomical draftsmanship, already incomparably beautiful, developed astonishingly over the next quarter-century.

## The theater of wonders

Leonardo loved theater and parties. The ephemeral art of entertainment, with its automatons and mechanical marvels, was a splendid field for experimentation in which

In February 1491 a great celebration was held at court for Ludovico Sforza, in honor of his marriage to Beatrice d'Este, noble daughter of the ruler of Ferrara. Leonardo designed bizarre allegorical costumes for the gala event, such as the strange trumpeter seen here and a number of monstrous and exotic wild men. Five years later, for Baldassare Taccone's play *Danae,* performed at Giovan Francesco Sanseverino's palace, he fabricated extraordinary theatrical machinery that transformed the protagonist into a star (opposite, below).

he could test his ideas and inventions and express his taste for literature, psychology, engineering, and symbol. On 13 January 1490, at the Castello Sforzesco, Ludovico's great palace in Milan, he designed the scenery for the Festa del Paradiso—the Feast of Paradise—staged in honor of the marriage of Isabella of Aragon and Gian Galeazzo Sforza, Ludovico's nephew. The text of the performance, written by Bernardo Bellincioni (1452–92), was somewhat rhetorical and specific to the occasion, but the mechanical marvels, which involved animated heavenly bodies, special light and sound effects, and songs—all devised by Leonardo—astonished the audience.

The Sforza Monument was to be almost double the height of contemporary bronze equestrian statues such as Donatello's *Gattamelata* in Padua and Verrocchio's *Colleoni* in Venice. In 1489, thinking Leonardo might abandon work on it, Ludovico approached the sculptors Filarete (c. 1400–c. 1469) and Antonio del Pollaiuolo to finish it. Still, on 23 April 1490 Leonardo wrote: "I…recommended the horse." The clay model was ready for the foundry on 20 December 1493.

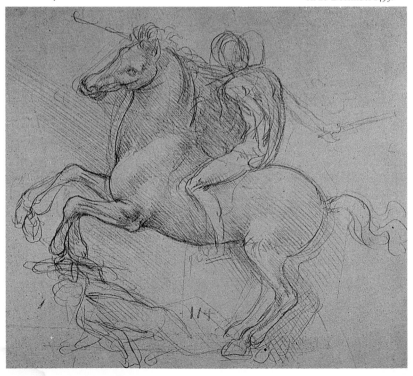

## Decisive events

In 1489 Leonardo had apparently at last received the Sforza contract he most longed for: the commission to cast an immense bronze equestrian statue in honor of Ludovico's father. He drew numerous studies for it and made a full-scale clay version, but the project seems to have progressed only by fits and starts for several years. Then, in 1494, the king of France, Charles VIII (r. 1483–98), invaded Italy, hoping to seize Naples from Alfonso of Aragon. Moving down the peninsula he first attacked Florence and Rome, throwing much of Italy into a turmoil of wars, alliances, and counteralliances. The Medici were banished from Florence. The German emperor Maximilian married Bianca Maria Sforza, Ludovico's niece.

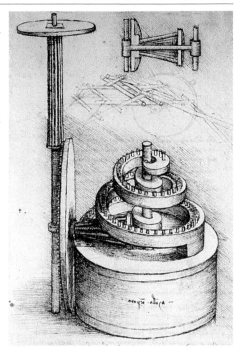

At first Ludovico thought he would benefit from the French king's expedition, but he subsequently joined the Italian coalition that overcame him in 1495. In November 1494 Leonardo, who had been planning at last to cast the Sforza equestrian monument, saw all his work go for naught: the bronze that had been set aside for the purpose—at least 66 tons (60 metric tons)—was sent to Ferrara to make cannon that would support Duke Ercole d'Este against the French.

The artist was still filling hundreds of pages with notes and drawings of his technological schemes. It is worth noting that Leonardo continued to dream of wealth: he designed a machine for sharpening needles and foresaw profits of 60,000 ducats a year. He persevered with his Latin studies; the language was an indispensable key to the scholarly circles that could be useful to him, despite his recurring contempt for them.

It was more than 23 feet (7 meters) high. Several studies made in 1493 show Leonardo's innovative process for the casting of this immense statue, from its structure in positive and negative to the use of fireproof clay for its mold. Opposite, above: a diagram for casting the horse's head; below: a sketch of the statue.

Leonardo's monumental vision is evident even in a drawing for a clock's spring (above).

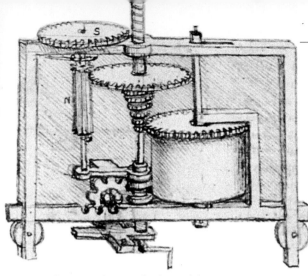

## Marvelous machines: clocks and looms

Leonardo's projects and studies were always interdisciplinary, his thought expressed by exchange and analogy. Designing a machine or sketching the composition of a painting, representing human anatomy (the microcosm) or the earth's "body" (the macrocosm)—all were similar procedures. He drew and analyzed the mechanism of a gun chassis or a clock as if he were performing an anatomical dissection: he took apart each element and observed every movement and phenomenon, from static structure to dynamic function, seeking the universal in the particular. He identified an object's materials, basic shapes, and essential qualities in order to understand it, so that he might transform it. For him painting, architecture, design, mechanics—art and science —were all aspects of a single enterprise: that of knowing the real world and envisioning a new world beyond the real—the poetic, eternal world of the imagination.

The determination with which Leonardo approached the study of clocks and looms is very significant. He devoted hundreds of notes and sketches to them, elaborations of machines with perpetual screws, sails, helices, and pendulums. He applied clockwork mechanisms to mills and "wind machines." He made splendid drawings to explain the problem of perpetual motion, writing: "O speculators about perpetual motion,

Around 1495, influenced by the architect Brunelleschi, who also designed clocks, Leonardo was studying clocks and clockworks (left) systematically and in detail, including systems of transmission of motion and power, gears and faces, counterweights and cogs, springs and hands, balance wheels and pendulums. In one case he even specified, "…and this without any sound." He drew spring-driven and weight-driven clocks, as well as water clocks. He investigated the striking mechanisms of clocks and bells as they related to both music and the telling of time. The rebus below, representing a falcon, is a word-play on time: *falcon + tempo = fal[lo] con tempo:* "take your time."

Concerning the invention of the mechanical loom Leonardo wrote in the *Codex Atlanticus*: "In importance, it comes immediately after the printing press, but is no less useful to men, it is a more beautiful and more subtle invention, that brings better benefits." Thus did he earn his reputation as the prophet of automation and the first engineer of the Renaissance to take up industrial design. He was interested in technology, especially in mechanical and automatic systems, because they saved time and energy and brought innovations to all realms of human activity. Anticipating robotics, he introduced certain principles of simultaneity and series into his loom design, which multiplied production capacities.

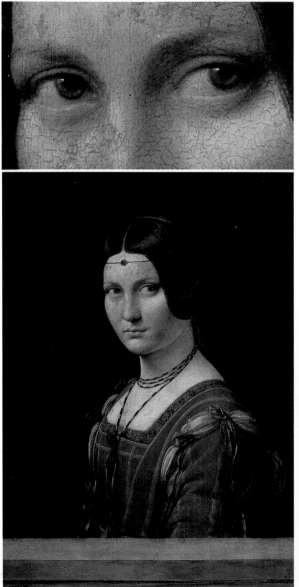

*La Belle Ferronnière* (left) is cited in a French inventory of 1642 as a "portrait of a lady of Mantua" by Leonardo. Its attribution to him is based on the pictorial technique, the psychological intensity of the sitter's gaze, the refinement of the clothing, the sculptural elegance of the figure, the treatment of space, the relationships between shadow and light, even the cracking of the surface. Nevertheless, the possibility of a mysterious second hand still hovers about this painting. The title refers, erroneously, to a lady with that appellation who was the lover of François I.

how many vain chimeras have you created in the like quest? Go and take your place with the seekers after gold."

## The Last Supper

At Ludovico's court Leonardo had been given a classical title, "the Florentine Apelles," reserved for the great painters. While he was pursuing his technical studies, Ludovico, by now proclaimed duke of Milan, commissioned him to paint *The Last Supper,* not as a panel painting but as a wall mural in the refectory of the Milanese convent of Santa Maria delle Grazie. This gave the artist an opportunity to test his idea of painting as a "*cosa mentale,*" a thing of the mind, and to synthesize in a single work of art his wide-ranging experiments in the fields of optics, musical harmony, anatomy, architecture, color, and perspective, as well as materials and techniques. Deep study of the movement of figures in space was at its source. Completed in 1498, the resulting work—Leonardo's most famous among his contemporaries—drew the praise and covetousness of kings and emperors, especially in France. From Louis XII

Damage to *The Last Supper* (below) began during Leonardo's lifetime. Over the centuries inept conservation efforts have covered and deformed his drawing and altered the chromatic values of his paint. The "restless masterpiece," as it has been called, has recently been the object of another, more studious restoration, begun in 1980 and intended to rediscover the original as far as possible. And indeed, colors, traces of highlight, and transparent effects—even the marks of the tip of Leonardo's brush—have been revealed.

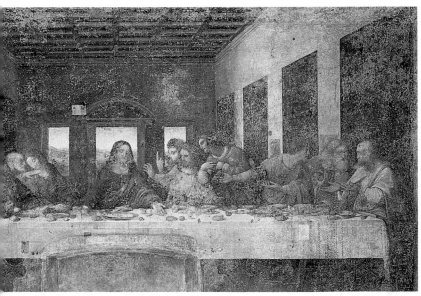

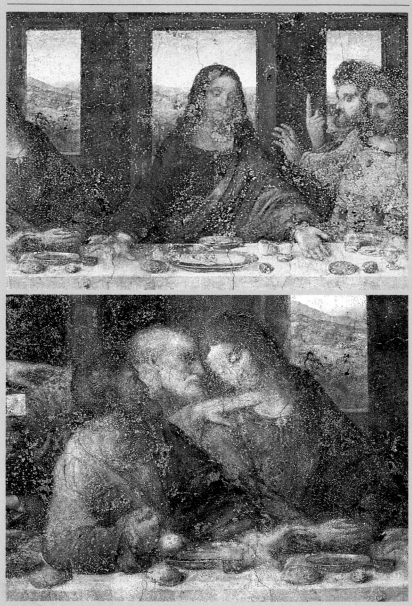

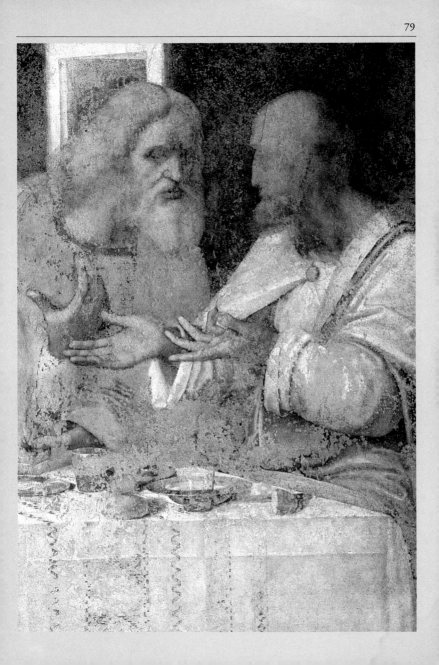

In lunettes above *The Last Supper* Leonardo painted garlands of foliage and fruit around the Sforza coats of arms and, within medallions, portraits of the dukes of Milan. In the Sala delle Asse in the Castello Sforzesco he painted a vast double allegory with political allusions, entwining *vinci,* rushes, and the Sforzas' *moro,* or mulberry; left: a reconstruction of the design; below: a detail of the ceiling mural. Seeking an emblem for his Achademia, he considered marine fossils (below, left) before choosing a version of the knot of *vinci* (see page 18).

and François I to Napoleon, they attempted to remove to France the wall on which it is painted. Fragile and delicate as the original tempera and oil were, the painting suffered serious damage.

## The intricate symbolism of tracery

In 1498 Leonardo, now forty-six years old, was hired to paint several rooms in the Castello Sforzesco: the Camerini, the Saletta Negra, and the Sala delle Asse (the latter rediscovered only in 1893). For these he devised a complex program of interlacing plant forms in which are intertwined emblems of Ludovico il Moro and references to archetypes such as the Eternal Return. A set of six engravings made by him or his studio and bearing the name of his Achademia (whose meaning is not clear) probably dates to this same period; in these, too, he elaborated naturalistic geometries, though in a more abstract mode that reinforces their symbolic aspects. Their style recalls certain Asian and Celtic motifs.

## Divine proportion

From his youth Leonardo had instinctively utilized mathematics and geometry—which, like music, "embrace everything in the universe"—in his work. These disciplines now increasingly commanded his attention. In 1496 he began systematic study with the Tuscan mathematician Fra Luca Pacioli (1445?–1514?), who came to Milan at the invitation of Ludovico. The concepts of the absolute and the universal fascinated Leonardo, who stated: "Let no one read me who is not a mathematician." And he added, with a neophyte's enthusiasm, "Learn from Messer Luca how to multiply square roots."

Although Leonardo made frequent absent-minded mistakes in the most elementary arithmetic, he achieved stunning results in geometry. After only a few months he was drawing the illustrations for Pacioli's new treatise, *De divina proportione*. In the collections of Sforza manuscripts in Geneva and Milan these are attached to cartouches like those of Leonardo's Achademia; they may have been taken from three-dimensional models like those which the Signoria of Florence commissioned from Pacioli in 1504.

DVODECEDRON ABSCISVS VACVVS

L eonardo drew polyhedrons (above) to illustrate the treatise on proportions by his friend the mathematician Luca Pacioli and reinterpreted the latter's "tree of proportions" with a naturalist bent (left). Pacioli came to be Leonardo's most important advocate at the Milan court, calling him a worthy successor to the legendary painters and sculptors of antiquity. He stated that Leonardo had written a "fine treatise on painting and human movement," now lost.

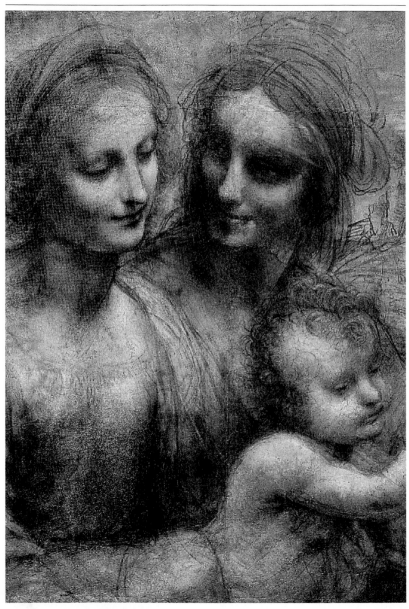

When Ludovico il Moro fell from power and the French arrived Leonardo left Milan, stopping in Mantua and Venice before returning to Florence. As Cesare Borgia's military engineer he traveled throughout northern and central Italy: the Marches, Romagna, Umbria, and Tuscany. In 1501 an envoy of Isabella d'Este, marchioness of Mantua, wrote that "the existence of Leonardo is so unstable and so uncertain that one might say he lives from day to day." He described Leonardo as "weary of the paintbrush, for he works fervently at geometry."

CHAPTER 4

# ART AND WAR

Between 1500 and 1517 the theme of *The Virgin and Child with Saint Anne* was at the heart of Leonardo's work. Opposite: a detail from a cartoon prepared for this subject, now in London. Right: the theme of the bridge, at once symbolic and practical, was dear to Leonardo, who devised a plan for spanning Istanbul's Golden Horn "from Pera to Constantinople" with an immense permanent structure 1,150 feet long (420 meters).

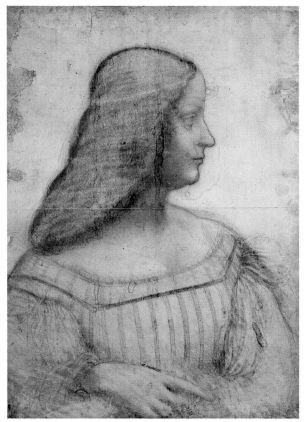

In a letter of 13 March 1500 the lute-maker Gusnasco of Pavia described a portrait of Isabella d'Este, marchioness of Mantua, that Leonardo had shown him in Venice. In 1501 Isabella sent for "another sketch of our portrait." The drawing (left) was perforated, a means of making a tracing by blowing powdered pigment through the pinholes. The perforations do not correspond exactly to the lines of the picture, which suggests that they were done by a master, not an assistant. (A more complete but less skilled version is in Oxford.) The strong profile and the fluidity of the draftsmanship help to identify this work as by Leonardo, although it has also been attributed to Boltraffio. Its poor condition makes a reading difficult and lends it a certain evanescent quality. Some sensitive retouching seems to have been done by another artist.

## The fall of Ludovico

In 1499, buoyed by his friendship with Luca Pacioli and by the general admiration aroused by *The Last Supper,* Leonardo set about consolidating his position at court, while pursuing his artistic and scientific investigations. He still hoped to cast the Sforza Monument. Just one year earlier the duke had given Leonardo a vineyard near the Porta Vercellina, Milan's Vercelli gate, to the west of the city.

That year Louis XII, newly crowned king of France (r. 1498–1515), declared war on the Sforza throne and laid claim to the succession of the Visconti, the ancient dukes

INSIGNE SVM HERONYMI
CASII

of Milan. Ludovico il Moro fled to Germany, seeking the protection of his nephew, Emperor Maximilian. At the time Leonardo was deep in the study of mechanics and hydraulics; he wrote *On Movement and Weight* and designed an apparatus "for the bath of the duchess Isabella." He had taken care, however, to send his savings to Florence and he now left Milan with Pacioli, remarking dispassionately, "The duke lost his estate, his personal fortune, and his freedom; none of his projects came to fruition."

The *Codex Atlanticus* contains a curious note from this time: Leonardo was planning a mysterious trip to central Italy with the counselor to the king of France, Count Louis de Ligny. He expected to meet the count in Rome and accompany him to Naples. Most of the note is written from right to left, as was natural for Leonardo, but four key words are written legibly from left to right. These state the principal objectives of the voyage: to go *arroma* (to Rome) and *annapoli* (to Naples) with *ligni* to get *ladonagione* (the donation). Was this reversal of habit intended to render them even more cryptic, or to make them intelligible to all readers? He also noted, in mirror writing, "Sell what you cannot take with you." In fact, Leonardo's first stop on the journey was probably Mantua and the court of Isabella d'Este (1474–1539), who was to become a patron and admirer.

L eonardo was in Bologna at the same time as his follower Boltraffio, who was painting the portrait below, marked with the initials C.B. (perhaps Costanza Bentivoglio). It bears on the reverse a macabre emblem (left) of the poet Gerolamo Casio. Casio was the author of a sonnet for Leonardo's *Saint Anne* and of the following verses, which he dedicated to the artist in 1525 and which play on the words *vincere* ("to conquer") and *Vinci:* "Nature, conquered by Leonardo da Vinci, / A Tuscan painter excellent for any State, / Impelled by envy and pitiless, / To Death said, go and conquer him who conquered me."

## A virtue of necessity

In the early 1500s Leonardo, a skilled military engineer, maintained careful

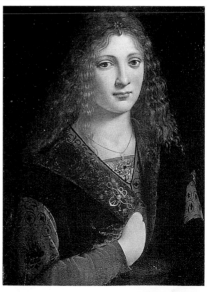

relations with the many quarreling princes of the day in a sort of uneasy balance. After seventeen years at the Sforza court he was obliged to turn for protection, friendship, and commissions to the same French rulers who had exiled his principal patron and murdered his friend the architect Jacopo Andrea da Ferrara, translator of Vitruvius. Working for the Republic of Venice in 1500 Leonardo planned systems of defense against a Turkish invasion of the city; some two years later he designed a bridge over the Golden Horn for the Turkish sultan, to connect the European and Asian shores of Istanbul. In Venice and again at Imola in 1502 he saw his future patron (the probable sponsor of the *Mona Lisa* and a *Leda*), the exiled Giuliano de' Medici, who was then planning to reconquer Florence.

When Arezzo rebelled against Florence Leonardo was undoubtedly in the area with his friend the military captain Vitellozzo Vitelli. In 1502–3 he traveled as a military engineer in the entourage of the warlord Cesare Borgia, usurper of the principality of Romagna; following Borgia's fall he returned to Florence. During this period he met Niccolò Machiavelli (1469–1527), the Florentine political philosopher and diplomat, who also accompanied Borgia for a time.

Above: a presentation letter addressed to Sultan Bayezid II of the Ottoman Empire, written from Genoa, accompanied Leonardo's plans for a bridge across the Golden Horn and for windmills. In the 1950s it turned up in a Turkish translation in the imperial archives in Istanbul. Below: this view of the Tuscan city of Arezzo and the nearby valley called the Valdichiana is both landscape and topography, bird's-eye perspective and surveyor's study.

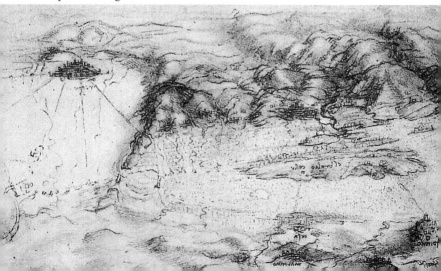

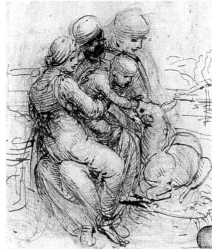

## In Florence once more

The city to which Leonardo returned was no longer that of Lorenzo the Magnificent, whose tyranny was execrated even while his rule was nostalgically lamented as a Golden Age. The city had not long recovered from the influence of the fervent iconoclastic preacher Girolamo Savonarola (1452–98), whose ascetic moralism and "Bonfire of the Vanities" had left a sour aftertaste. A certain ebullience was missing in the painters' workshops where Leonardo found his companions of yore. Ghirlandaio was as well regarded as ever, but Botticelli was out of fashion. Verrocchio had died in 1488. Twenty years earlier Filippino Lippi had inherited from Leonardo two important painting commissions, the altarpiece for the chapel of San Bernardo and *The Adoration of the Magi;* now Lippi passed on to Leonardo a commission from the friars of the Servite order for their church of Santissima Annunziata. Leonardo set to work on studies for a *Virgin and Child with Saint Anne* that he did not finish. In the early years of the century

I n 1501 Leonardo made at least one drawing (described in a letter to Isabella d'Este from her agent) for the Servites' commission for the church of Santissima Annunziata. The order, whose attorney was Piero da Vinci, enjoyed the patronage of Mantua. No extant work matches that description, but a study inscribed "Leonardo at the Annunziata" is attributed to him, as well as the preliminary study for the *Saint Anne* now in Venice (above). There is also a painting based on it, attributed to Andrea del Brescianino. Left: two sketches for windmills, possibly connected to Leonardo's proposal for the Ottoman sultan.

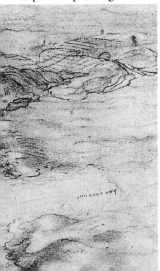

Leonardo was thus mainly in Florence, though he also journeyed to Rome, where he made notes on the mills by the Tiber River and on the Emperor Hadrian's villa at Tivoli; these famous antique

ruins introduced new stylistic and thematic elements into his work, classical and mythological.

The luxurious life at the court of Milan was long past, yet Leonardo continued to find commissions and to deposit gold florins into his account at Santa Maria Nuova, a charitable institution and bank in Florence. At the request of the marquis of Mantua he advised on plans for a villa and proposed to make a scale model of it, commenting that for it to be perfect it would have to be set in the lovely Florentine hills. In Florence itself his architectural expertise was sought concerning the campanile of the church of San Miniato, the stability of the church of San Salvatore al Monte, and the placement of Michelangelo's *David,* completed in 1504. His oddest job, perhaps, was as an antiques appraiser, assessing four antique vases from Lorenzo de' Medici's collection for Isabella d'Este in May 1502.

### A revealing correspondence

Isabella of Mantua was the most erudite woman in Italy. Leonardo had drawn her portrait in about 1500, probably while visiting her city. She now corresponded with agents in Florence, seeking to have him do a second portrait, and these letters contain intriguing information about the artist's fields of study and his workshop there. Two works of 1501 are accurately described: a small *Madonna* and a large drawing for *The Virgin and Child with Saint Anne,* now probably lost.

One of these correspondents, Fra Pietro da Novellara, noted in his reply of 3 April 1501 to Isabella's letter of 27 March that Leonardo "works fervently at geometry" and "sometimes puts touches to portraits being painted by two of his pupils." In his letter of 14 April the friar opined that "his mathematical experiments have so

Doubtless following his journey to Rome, Leonardo turned to mythology for inspiration in studies such as this *David* (below) and a *Neptune*. Left: a note from this trip, in which he writes of having seen Hadrian's villa at Tivoli.

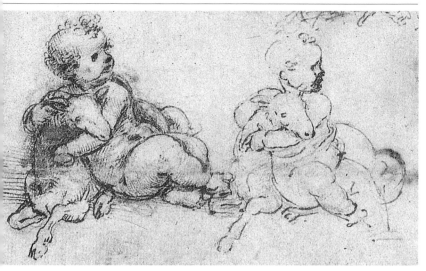

distracted him from painting that he can no longer tolerate the brush" but added that he had promised to fulfill the marchioness's request as soon as he finished a *Madonna with a Yarn-Winder,* a "small picture" for Florimond Robertet, secretary to Louis XII.

Leonardo was attempting to postpone Isabella's commission with the excuse of his commitment to the king of France and his passion for mathematics. It is interesting to note that this exchange took place over the course of just a few days. Equally swift (if unsuccessful) were negotiations with Duke Ercole d'Este, who wrote from Ferrara on 19 September to the French regime in Milan, attempting to obtain Leonardo's molds for the casting of the Sforza Monument. As early as 24 September the Este ambassador received a tentative reply from the affirmative from the cardinal of Rouen, who nevertheless advised him to speak directly to Louis XII. Nothing ever came of this. It is not surprising that Leonardo, who was in Florence with Pacioli, continued to devote himself to his studies of arithmetic and geometry. On a sheet with studies for *The Virgin and Child with Saint Anne* (probably drawn in 1501) and for a rolling mill for gold and lead, he scrupulously copied an excerpt from the

Children at play are a recurring theme in Leonardo's work, often bearing a pagan and esoteric meaning, as in the *Leda,* or, when a child is playing with a lamb, a theological one. Raphael adopted this iconographic device in various versions of *The Holy Family* (below: a detail).

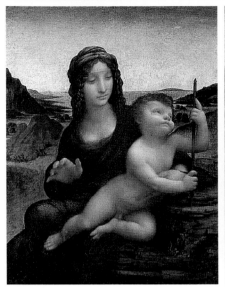
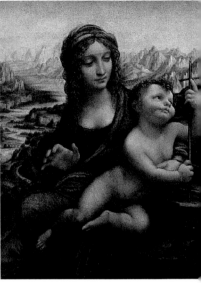

Latin translation of a geometry codex by Savasorda, a Jewish Spaniard of Arab extraction whom Pacioli knew well. Three years later the Neapolitan poet and humanist Pompeo Gaurico wrote in his treatise *De sculptura* that Leonardo was "the best-known of Archimedes' followers."

## Traveling for Cesare Borgia

In the spring of 1502 Leonardo was residing in Florence, although he was working for both the French and the lord of Mantua. He had just turned fifty. That summer he left the city to put his military talents at the service of Cesare Borgia (1475–1507), captain general of the papal army, the son of Pope Alexander VI, and model for *The Prince,* Machiavelli's treatise on political power. With the protection of the French he was building a powerful state in central Italy. He had been at the side of King Louis XII during the latter's triumphal entry into Milan and had certainly met Leonardo, whom he dubbed "our most excellent and dearly beloved architect and general engineer" in a passport issued to the artist on 18 August 1502 at Pavia, where the French king held court.

Above: among dozens of extant versions of *The Madonna with a Yarn-Winder,* two especially seem to have been painted in Leonardo's workshop, from his drawings and with his participation. Their composition, revolving around a diagonal axis, and their dimensions are identical.

CAESAR

Borgia, who had granted himself the titles of *Gonfaloniere* of the Holy Roman Church, prince of Romagna, and lord of Piombino, commissioned Leonardo to study the cities and fortresses of his domains and ordered all the *condottieri* (captains) and engineers under his command to assist him with men and means. This new commission given to Leonardo cannot have displeased the French; the Florentines, on the other hand, must have been dismayed, for they were striving to contain Borgia's thirst for conquest and to maintain their freedom from him.

From August through the following February Leonardo journeyed through Emilia Romagna, the Marches, Umbria, and Tuscany. He kept detailed travel notes in a little book barely 4¼ x 2¾ inches (11 x 7 cm), now called *Manuscript L*. Thus, in Urbino on 30 July he sketched a dovecote, Luciano Laurana's monumental staircase for the ducal palace, and the chapel by Bramante called the Cappella del Perdono; with impressive skill and the use of a compass he made an accurate survey in four pages of the citadel's fortifications. In the following days he drew the library at Pesaro. On 8 August he made notes on the musical harmony of the jets of a fountain in Rimini; in Cesena on 10 and 15 August, while commenting on the local fair and the town's architecture, he scribbled a sketch of the ramparts and some related calculations; finally, on 6 September, at three in the afternoon, he was to be found immersed in drawings for the port at Cesenatico.

## Geography as art

His *Map of Imola* and *Physical Map of Tuscany, Emilia, and Romagna* are among Leonardo's most significant sheets, brilliant examples of the interaction between the

Symbols abound in *The Madonna with a Yarn-Winder* (opposite): the spindle represents the future of the cosmos; the thread, destiny; the double cross refers to both the Passion and the Tree of Life. The landscape in the version on the right contains symbolic elements such as the road, bridge, and mountain that are also seen in other paintings by Leonardo.

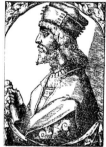

Sigmund Freud wrote: "[Leonardo] accompanied Cesare in a position of authority during the campaign [above] that brought the Romagna into the possession of that most ruthless and faithless of adversaries. There is not a line in Leonardo's notebooks which reveals any criticism of the events of those days, or any concern in them."

Left: the letter-patent and passport issued by Cesare Borgia for Leonardo in August 1502.

Grsfia Duca. omandiele valoritea Prinea Hadrie Dorenus Ilumbur. Ac nius Generalis Ad Tutti nri Locotenenti Castellani Capitany Conductteri officiali... Commettemo et Comandamo che al nro Prefan et Diletisfimo Familiare Archi-tensore el quale de nra Comusfione ha da confiderare li Lochi et Forte de li Stati io possiamo prouederli Debano dare per tutto pesfo libero da qualung publico pagamento efsurare et bene extimare quanto uorra Et ad questo effetto Comandare homini ad ... et Fauore recercara volendo che dellopera da farfi neli nri Dominy Qualung suo conformarfe Ne de questo presuma alcuno fare lo contrario per quanto li sta ... apie die Decimo ottauo Augusti Anno Domini Millesimo Quingentesimo secundo

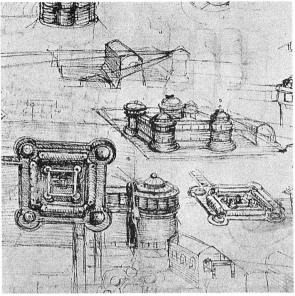

art of cartography and the science of geography. These are two attempts at synthesis, representing the sum of the cartographic technology of the time—all that was known of terrain, geometry, cosmology, anatomy, and aesthetics. The first of the two maps, the circular *Map of Imola,* is as intense as a mandala; it looks quickened with teeming life, like a microorganism. The second resembles the ramifications of a system of veins, arteries, and capillaries. In his *Physical Map* Leonardo presented a primal and timeless vision of the earth's surface that raised topography to the level of poetry. These bird's-eye geographies illustrate the dominion of learning

and of strategic and intellectual power, the realm ruled by perspectives both mental and symbolic. They recall the parallel that Machiavelli drew between "those who draw territories"—that is, mapmakers—and the Prince, whose aim is "to learn the nature of their peoples." In August 1503 Cesare Borgia's empire collapsed and he fled to Spain. Leonardo returned to Florence.

On 24 October 1503 a new twist occurred in his life: he received the key to the Sala del Papa, the Hall of the Pope in the Florentine church and hospital of Santa Maria Novella, to use as a workshop in which to execute the cartoon for *The Battle of Anghiari,* an immense mural commissioned by the city government. This famous

Opposite, above: practical fortifications; below: a map of Imola conceives the city in rational terms, as an "urban machine," marked with sixty-four surveyor's terms and the eight points of the compass; below it, the natural force of the river lashes like a whip. Above: the hydrography of Tuscany as an anatomy of the land.

work was painted on the wall of the Grand Council chamber in the Palazzo della Signoria; it was later destroyed and is today known only through archival documents, Leonardo's memoranda, copies by other artists, and by legend.

## The school of the world

For Leonardo, as for other artists of his time, the battle painting presented an ideal decorative opportunity for displaying grand visual and emotional effects. On 30 August 1504 he received materials and pigments in quantities that confirm the vast scale of the project: it was a scene more than 22 feet 9 inches high x 55 feet 3 inches wide (7 x 17 meters), depicting the victory in 1440 of the Florentines, allies of the pope, over the Milanese under the command of the *condottiere* Niccolò Piccinino.

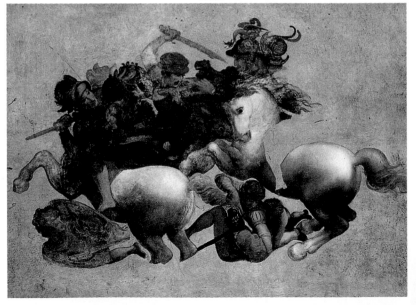

With this immense undertaking Leonardo challenged himself, Florence, and his rivals. Foremost of these was his fellow Florentine, the much younger Michelangelo Buonarroti, who had always been antagonistic toward him and who had obtained the commission for a painting of *The Battle of Cascina* for the facing wall. Despite the excitement of this "battle of *Battles*," neither work was ever completed. Leonardo seems to have ceased work on his wall by 1505 and Michelangelo made only the cartoon for his before going to Rome. Together they would have created "the school of the world," as the sculptor Benvenuto Cellini said, a model for future artists.

Leonardo did paint much of the central figure group of horses and riders, a knot of violence and fury. It was done in oil on a dry wall, not fresco, and was therefore fragile. Leonardo was always experimenting with new techniques, and tradition has it that the first part of the painting was ruined by one of these: the fire he is supposed to have lit to help the paint dry, after the fashion of the ancients, is said to have destabilized the pigments, causing them to dissolve. Another theory is that his materials were of poor quality. Whatever the truth, documents prove that the middle of the battle scene, called *The Struggle over the Banner,* remained visible for many years before it fell into absolute ruin and was covered by Vasari's frescoes in the Salone dei Cinquecento.

A number of Leonardo's drawings and notes for *The Battle of Anghiari* have survived, among them three studies of heads (opposite, above, and this page). Copies and studies by other artists, from Raphael to Rubens, also exist. Above: a horseman from *The Battle,* sketched by Leonardo over a study of human proportions. The chief pictorial evidence for the work is the sketch known as the *Tavola Doria* (opposite), which is variously identified as an experimental panel by Leonardo himself or as a copy of the mural.

## Military architecture

In his religious architecture Leonardo favored the octagon, and in his urban planning he drew cities in tapered shapes, but in military architecture his originality lay in his use of the circle, that ideal and functional shape. However, in drawings made between 1502 and 1504 there

appears a curious repertoire of architectures: pyramids
and star-shapes, step designs, square and polygonal
plans, and concentric structures that are half spiral, half
labyrinth. Leonardo imagined the most various defensive
systems, such as passageways that could be flooded or set
on fire and secret stairways as provisions against betrayal.
On a single sheet, beside drawings of circular fortifica-
tions, he made notes about the moon and optics,
criticized Botticelli's ideas on perspective in landscape,
mentioned his student Salai three times by name, and
pondered the cost of draft animals.

In the fall of 1504 he interrupted work on *The Battle of
Anghiari* to go to Piombino, a port town on the Tuscan
coast that was strategic in the ongoing rivalry between
Florence and Pisa. Notes on that visit are contained in a
text in Madrid called *Madrid Manuscript II.* He wrote
that he had worked there on 20 November and that on
All Saints' Day, 1 November 1504, he had "performed
this demonstration for the lord of Piombino," that is,
advising him on the building of fortifications. He made
several design proposals: a "covered road" between the
existing citadel and a tower that was to be 20 spans
high (100 feet, or 32 meters) and 25 spans in diameter
(125 feet, or 40 meters); a "trench with straight sides"
between the new tower and the city gate; and another
trench or moat 1,235 feet long (380 meters) between
the citadel and the Rocchetta, a castle that guarded the
port. He worked out a cost estimate: 585 ducats for the
tower; 2,099¹⁄₁₆ ducats for everything. On this same sheet
are jotted notes concerning painting theory ("darkness
is the absence of light") and surprising observations

In Piombino, reading a
text by Francesco di
Giorgio at the seashore,
Leonardo doodled waves
in the margin of the page
(top). Above: drawings
for military fortifications
look like fantastic set
designs or ideal citadels:
the architecture of the
imagination.

on the senses of hearing, smell, and sight in cats.

These notes on architecture reveal Leonardo's interesting relationships with other engineers. The Florentine architect Antonio da Sangallo (1455–1535) was in Piombino with Leonardo and is mentioned in his notes on sailing. Leonardo studied the treatises of Francesco di Giorgio, wrote or drew responses to them, copied and annotated passages, and adapted their drawings to a project for the port of Piombino involving square

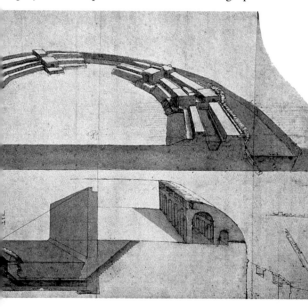

"On the 9th of July 1504, Wednesday, at seven o'clock, died ser Piero da Vinci, notary at the Palazzo del Podestà, my father—at seven o'clock, being eighty years old, leaving behind ten sons and two daughters." This dry statement, jotted on a manuscript among some sketches (above) in normal (rather than reversed) writing, may seem rather cold and detached, but Leonardo's repetition of the precise hour of death betrays his emotion. Piero did not include him among his heirs, but the next month his uncle Francesco made him sole heir.

towers, semicircular sea walls with openings protected by a "great wall," and systems for building out over the sea.

## Between Florence and Milan

In the early months of 1504 Leonardo worked on *The Battle of Anghiari* in Florence and received payment accordingly. During the same period he bought eighteen notebooks and received other offers, including, from Isabella d'Este of Mantua, a request to paint a *Christ Child*. His uncle Alessandro degli Amadori, canon of Fiesole, corresponded with her on the subject, and his student Salai

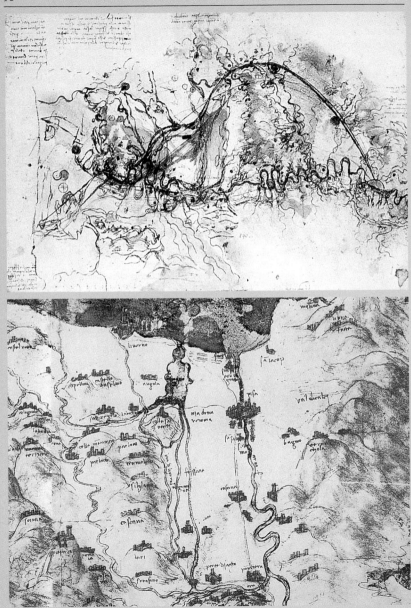

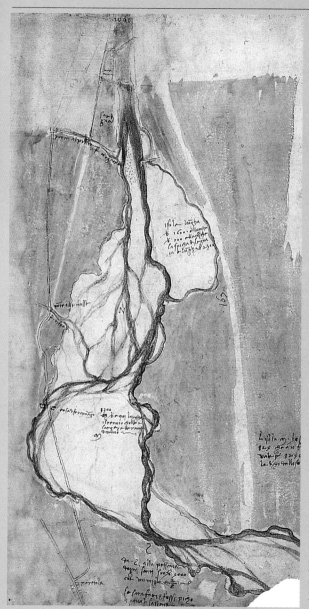

In Florence Leonardo had the chance to develop an ambitious project he had pursued for thirty years: the deviation of the Arno River. At the turn of the century he had conceived a hydrologic system that would serve practically every town in Tuscany, assuring a regular supply of water, drainage and irrigation of the land, and improved transportation along a navigable waterway. There would be military applications as well: the riverine network could act as a defense against invaders and a means of blockading supplies coming by sea to Pisa, Florence's enemy. On 22 August 1504, with Machiavelli's support, work was begun to divert the Arno away from Pisa into two canals in the direction of Stagno and the sea, with a dam at Torre a Fagiano. The much-ridiculed scheme failed, though a modern antiflooding project resembles it. Three studies from around 1503 reflect Leonardo's ideas. Opposite, above: a first, gestural sketch sets out the concept; below: the area of Pisa and Leghorn is described iconically; near left: an analysis of the Arno near Florence in anatomical terms—as a system of arteries. This grand conception was, in effect, a sort of earth art, a monumental, aesthetic transformation of terrain.

proposed "to do something gallant" for the marchioness.
No such painting for Isabella was made, however.

At this time Leonardo returned to Vinci more often
than it might appear. He planned to excavate a lake
among the hills, studied a nearby mill at La Doccia,
drew the line of the Montalbano hills, and calculated
distances to Pisa. On these same sheets he made notes on
how to grind colors and drew an adjustable "pebble oil"
(gasoline) lantern for painting in dim light. He had
previously imagined a painter's studio with movable
walls to control natural light and an elevator with which
to put a painting away at the end of a day's work.

Litigation regarding *The Virgin of the Rocks,* ongoing
since 1483, was resolved on 27 April 1506 and Leonardo
and Ambrogio de Predis were ordered to finish the
work (presumably the second version) within two years.
Leonardo was still taken up with *The Battle of Anghiari;*
nevertheless, on 30 May 1506, upon the pressing request
of the French government, Florence authorized him to
interrupt work in order to go to Milan. He promised
to return within three months, a contract that he was
to break. On 18 August Charles d'Amboise, the French
governor of Milan and the king's lieutenant, issued a
first request that Leonardo's stay there be extended.

There began a diplomatic back-and-forth between
the Florentines and the French. Finally, on 14 January
1507 King Louis XII let it be known, from his court
at Blois, that he wished Leonardo to be allowed the
time he required to paint "some works by his hand."
On 22 January the Signoria of Florence was obliged to
acquiesce, writing, "There is nothing more to be said."
The artist appears to have created an international
incident.

He began shuttling between Tuscany and Lombardy. In
March he was in Florence and Vinci. His uncle Francesco,
who had made Leonardo his only heir, had died; his
brothers were contesting the legacy. There followed a
long, rancorous quarrel, in which Leonardo sought
powerful supporters. Charles d'Amboise intervened in
his favor from Milan and Florimond Robertet, the king's
secretary, asked the Signoria of Florence to resolve the
matter quickly, since it had caused "the king's painter" to

In Florence Leonardo
developed both the
Christian iconography
of the *Saint Anne* (right)
and the pagan eroticism
of *Leda and the Swan.* He
prophesied the flight of
man and drew a fantasy
construction (above),
reminiscent of the utopian
architectural visions of
the Enlightenment. This
mausoleum, however, was
inspired by an Etruscan
tumulus like the one
discovered in Castellina,
in the Chianti region of
Tuscany, on 29 January
1507. In plan it is a
symbolic wheel with
cruciform spokes, a
"multiplication" of the
tomb; details of the burial
niche are given in section.
Leonardo was seeking the
universal forms that
possess—as the architect
Andrea Palladio remarked
of the Pantheon in
Rome—"the figure of
the world."

interrupt "a picture that is very dear to [the king]."

In early 1508 Leonardo sent Salai to Milan. "I am almost at the end of my litigation with my brothers, and…I hope to be with you at Easter and carry with me two pictures on which are two Madonnas of different sizes which I began for the most Christian King, or for whomsoever you please," he wrote in the *Codex Atlanticus*. Two subjects from the Florentine period may correspond to

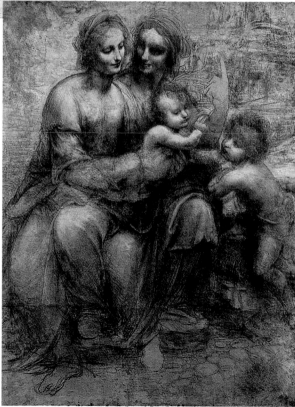

During his outings Leonardo pursued studies of nature for his *Codex on the Flight of Birds* (above: a detail) or sketches of flowers for *Leda and the Swan* (overleaf). In that painting are recognizable marsh reeds, a toad (symbolizing death), a primula, a daisy (token of love), columbine (hidden love), and jasmine (homage to love). He continued to work on the subject of the *Virgin and Child with Saint Anne,* the cartoon for which survives (left); it corresponds to paintings from his workshop, but to no autograph work.

these paintings: *The Virgin and Child with Saint Anne* and *The Virgin with Two Playing Children*.

What works did Leonardo undertake for the French in Milan? In a letter of 16 December 1506 that he sent to the Signoria of Florence, Charles d'Amboise stated that he had "loved" Leonardo for his "excellent works" before meeting him and that if he was "already famous for painting," he was not so for the other gifts he possessed, in particular for his "drawings, architectures and other things that we required." The studies for his villa are no doubt among these.

## Leonardo, Raphael, and the "modern manner"

During his years in Florence Leonardo had manifestly influenced Tuscan artists such as Fra Bartolomeo and Andrea del Sarto with his soft painting technique and unique treatment of space and light. Works of Leonardo's school and interpretations of his themes are sometimes attributed to artists such as Bachiacca, Franciabigio, and Giuliano Bugiardini. Vasari maintains that the great Mannerist painter Jacopo da Pontormo (1494–1557)—who was no more than twelve at the time—became one of his pupils, and sees in Leonardo an anticipation of

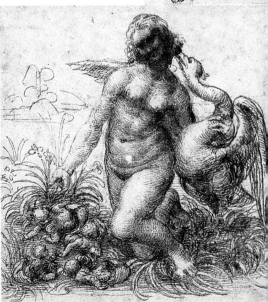

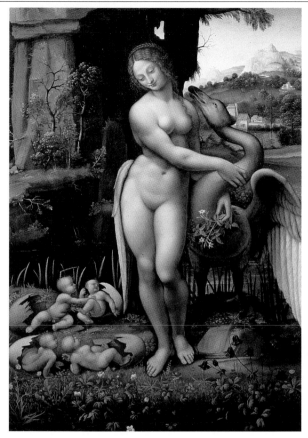

Leonardo's theme of Leda/Nemesis was popular: there are autograph drawings from the years 1504–13, such as *Leda Kneeling* (opposite, below); studies by other artists, such as Raphael's standing *Leda* (opposite, above right); workshop versions (near left); interpretations with echoes of the original, such as Pontormo's (opposite, above left); and myriad engravings, sculptures, and literary citations. Leonardo saw the classical myth, in which the union of the divine and the human engenders both beauty and strife, as a vehicle for the synthesis of his formal and symbolic studies. A lifelong curiosity drove him to try to understand the interaction of the elements—earth, air, water, and fire. Leda is nurturing nature, symbol of fertility and modesty, primordial Mother Earth; in the myth she is conflated with Nemesis, daughter of Night and sister of Death, who rises from the marshland by the fountain of life. She is seduced by Jupiter (Zeus), father of the gods, in the form of a swan. The children of this union, two pairs of twins, are the divine Castor and Pollux and the mortal Helen and Clytemnestra, symbols of both grace and vanity.

Mannerism. Leonardo's followers spread his style and his iconographic repertoire from Siena to Spain. References to *The Battle of Anghiari* and versions of *The Virgin with Two Playing Children* and *Madonna with a Yarn-Winder* abound. Raphael familiarized himself with the works of Leonardo; his interpretations of *Leda and the Swan* and other images by the older artist, some of which date to before 1506, may be based not on completed paintings but on studies. There are obvious similarities between the *Mona Lisa* and Raphael's *Portrait of Maddalena Doni,* painted in 1506.

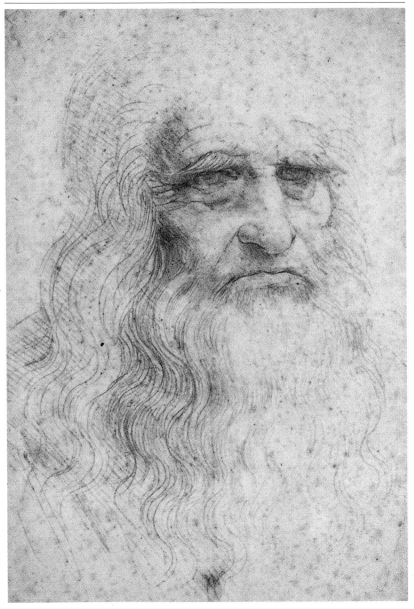

In September 1508 Leonardo, painter to the king of France, left Florence for good. His return to Milan opened new horizons of thought and study: "I will not concern myself here with proofs, which will reveal themselves anon, when the work will be put in order; I will only concern myself with finding problems and inventions…. Do not mock me, reader, if we here make great leaps from subject to subject."

CHAPTER 5

# MILAN, ROME, AMBOISE

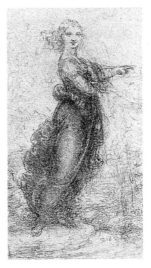

A myth has developed around the artist in which he is portrayed as a wise old man, a near-seer, half Plato, half Faust. Opposite: the self-portrait most likely to be authentic dates to around 1515 (Leonardo was then sixty-three years old). Right: his sketch, *The Young Girl Pointing beyond the Visible.*

## Manuscripts constructed like hypertexts

In March 1508 Leonardo was living in Florence, collecting his notes for a work that was to form part of the *Codex Arundel:* "This will be a collection without order," he wrote, "made up of many sheets which I have copied here, hoping afterwards to arrange them in order in their proper places according to the subjects of which they treat." In a note he revealed his methodology, along with his apprehensions: "Take care of all these matters tomorrow, copy them, then mark the originals with a sign and leave them in Florence, so that if you lose what you take with you, the invention will not be lost."

On 12 September, once more in Milan, he began to put together an *omnium gatherum* document now known as *Manuscript F,* an assemblage of thoughts on astronomy and optics, a theory of shadows, observations on geology, hydraulics, and the flight of birds, and references to the Roman architect Vitruvius and the 15th-century Florentine mathematician, architect, and painter Leon Battista Alberti (1404–72).

Another key document is the *Codex Leicester,* a manuscript from the period of transition between Florence and Milan. This is essential to an understanding of Leonardo's method of compilation: like a commonplace book, it gathers scattered notes and reflections, autobiographical recollections, quotes from ancient and contemporary sources, references to his other papers and notebooks, and excerpts from them. To these are added further comments and observations on points meriting reexamination, new questions and judgments on old problems, and accounts of discussions and new experiments. These are assembled in a disorganized mass and intermixed with

In the *Codex Leicester* (above: a sheet) Leonardo studied astronomy and had remarkable insights about the halo of the new moon.

drawings, diagrams, plans, and figures; Leonardo promised himself to compose a new, systematic, and definitive corpus from all this, but he never did. He proceeded by hypothesis, question, and analogy. The revisions, underlinings, additions, and crossings-out that interrupt the flow of his sentences are evidence of the extraordinary spontaneity of his thinking.

## "Here is revealed the experience that gives birth to certainty"

One component of Leonardo's genius was his remarkable ability to study phenomena, to infer causes from his observations, and to intuit the reasons for the way things work. Optics lie at the center of his inquiries into the theory and practice of painting. He had been interested in the subject since 1490 and took it up again in a manuscript of 1508–9. For him "painting is concerned with all the ten attributes of sight, namely darkness and brightness, substance and color, form and place, remoteness and nearness, movement and rest."

The eye is also an instrument of geometry "according to the laws of mathematics." How vision works was one of the great puzzles of classical thought. To explore this subject Leonardo turned to the traditional authors, many of whom had written treatises on optics: the ancient Greek physician Galen (AD 129–c. 199), the Muslim scientists Avicenna (980–1037) and Alhazen (965–1039), the English clerics and philosophers Roger Bacon (c. 1220–92) and John Pecham (d. 1292), the Polish scientist Witelo (c. 1230–after 1275), and finally Leonardo's own contemporaries, the Florentines Lorenzo Ghiberti (c. 1378–1455) and Leon Battista Alberti. At first Leonardo adopted Alberti's notion, based on his concept of perspective, that vision operates as cast light does, in an imaginary cone of space between the eye and the objects viewed; its central ray is on an axis with the center of the

Leonardo performed all sorts of experiments concerning vision (above). He devised complicated systems of intersection and refraction of light, using lenses, glass balls (below, left), and mirrors to simulate the structure and functions of the eye. With no precise idea of the role of the retina or the phenomenon of the inversion of images, he displayed remarkable intuition when he observed that common sense does not transmit exact images to the intellect, but that vision is imprecise and full of ambiguities. He applied his observations on anamorphosis, composite perspectives, and the variety of apparent forms to his paintings. His research on the colors of shadows, refraction of light, and the spectrum anticipate the theories of the Impressionists.

pupil. He applied this concept to speculations on light, color, sound, and gravity, among other things. Might the vanishing point in perspective coincide with the silence point in acoustics?

In his first studies Leonardo had accepted the idea of the ancients that the eye sees by emitting "visual rays" that move toward objects. He later took the medieval view according to which the eye receives rays of light as particles emitted by the objects. Finally, in the text now known as *Manuscript D*, he stated: "The pupil of the eye has a power of vision all in the whole and all in each of its parts…. Here the adversary says that the power of vision is reduced to a point"; in *Manuscript F* he noted that vision is "stretched all along the pupil of the eye."

## The mechanics of the universe

Despite his old suspicion of academics, Leonardo delved often into the writings of earlier scholars. Before 1500 he had discussed Aristotle, critiqued the 14th-century German Scholastic Albert of Saxony (1316–90), who had written on mathematics, physics, and logic, and examined the late-medieval notions of the French philosophers Jean Buridan (1300–1358) and Nicole d'Oresme (c. 1325–82). But these were only partial sources. A scientist himself, Leonardo performed experiments in physics and applied the conclusions to art and other fields. The analysis of forces—weight and motion, inertia and equilibrium, and the principle of balance—revealed to him the mechanics of the universe; from these studies he formulated an idea of the harmony of proportions that he applied to music and architecture. In the course of studying dynamics he reexamined classical and medieval theories. In *Manuscript I,* when he asks, "What is the cause of movement?… What is impetus?… What is percussion?" he is echoing classical sources. Always an empirical thinker and believer in evidence, he admonishes: "You investigators therefore should not trust yourselves to the

L eonardo studied motion and equilibrium in quick, shorthand sketches (above) and gave his fountains and lanterns (below, left) the appearance of animated models for monumental architecture.

T he small painting opposite has been identified as the "disheveled young woman, sketch, work of Leonardo da Vinci" mentioned in a 1627 inventory of the Gonzaga family. Partly drawn with a brush, partly highlighted with white lead on uncoated wood, this seems to be Leonardo's only improvised work.

authors who by employing only their imagination have wished to make themselves interpreters between nature and man, but only [to the guidance] of those who have exercised their intellects not with the signs of nature but with the results of their experiments."

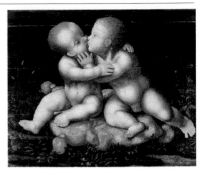

## Gardens of delight

Once reestablished in Milan, Leonardo began to work for Charles d'Amboise. He designed a villa (never built) for him in the San Babila district of the city, for which he proposed a spectacular garden with watercourses to be diverted from city canals. This gave him the chance to devise ornamental waterworks and gardens of wonders. He took his inspiration from the legendary fountains of antiquity, such as that of the Greek scientist Hero of Alexandria, and drew from the writings of the Sienese engineers Taccola and

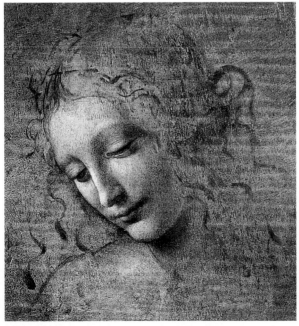

Leonardesque paintings of the embrace of the child Jesus and young John the Baptist are known, though none is by Leonardo's hand. The theme is taken from the Apocryphal Gospels and combines sacred and esoteric symbolism. This unattributed painting on wood (above) possesses fine qualities, despite some *pentimenti*. The *Salvator Mundi,* with its blessing gesture, is another work by Leonardo known only through versions by his followers (below and page III, detail). There are also some autograph drawings in the Windsor Castle collection.

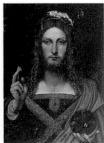

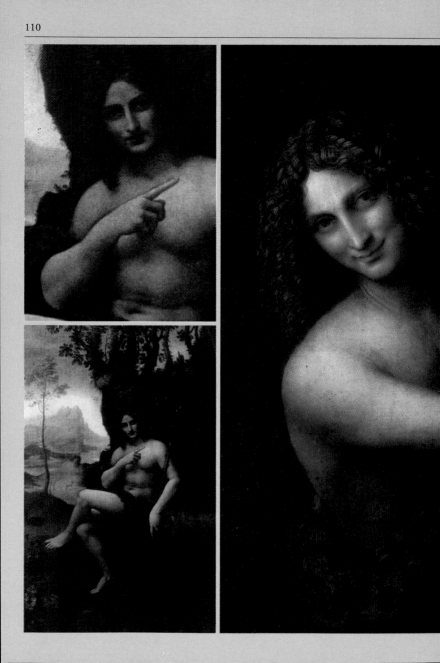

After *The Virgin of the Rocks,* Leonardo evoked its magical aura in several other paintings with themes that are half sacred, half Dionysian. These works feature figures making cryptic gestures and wearing the compelling, enigmatic expression known as the Mona Lisa smile. We are far from the pathos of *The Adoration* and *The Last Supper:* these are apparitions—hieratic, ambiguous, disturbing, and heavy with allusion. The gesture indicates what lies beyond the visible, projecting a charismatic and mysterious energy. *Bacchus* (opposite, above and below) was originally *Saint John the Baptist in the Desert,* retouched in the 17th century and converted to a paganism that seems to sit well on it. Another autograph *Saint John the Baptist* (center), with its esoteric, androgynous, even slightly diabolical quality, inspired the Decadent poets of the 19th century. It represents the high point of Leonardo's poetics of enigma. *The Angel of the Annunciation,* reinterpreted by a student from a drawing by Leonardo and endowed with an erect penis, claims to reveal the much-debated "sex of the angels." On the back are a few words in Greek, certainly in Leonardo's hand, on the subject of representing the invisible.

Francesco di Giorgio. He contrived innumerable surprise effects and gadgets: a wine cooler; a trick whereby little jets of water were to spurt up under ladies' gowns; musical instruments operated by watermills to a concert of natural fragrances. The garden would be covered by a fine-meshed copper screen, so as to be an aviary for every sort of bird. These devices bear some similarities to those of the Medici gardens at Pratolino. In addition he designed a colossal hydraulic clock, with an automaton that rang the hours.

He described a fantastic garden in which inventions mixed nature and artifice, calling this "the site of Venus" and relating it to the island of Cyprus, birthplace of the goddess of love. The fashion for such arcadian pleasure parks was growing; in Rome in 1516 the archbishop of Cyprus commissioned a garden to be decorated "with stories of Bacchantes, satyrs, fauns, and wild things" by the artist Perin del Vaga.

## The Trivulzio Monument

There appears on a leaf of the *Codex Atlanticus* a cost estimate for the "monument of Messer Giovanni Giacomo

Several of Leonardo's studies for an equestrian monument, such as the bronze statuette (attributed to him) or the drawing (both below), show a rearing horse. Others, such as the above sketch, show a horse at a walking pace, under whose hoof we see a tortoise, a reference to the Medici, and a vase out of which water pours, as if to exorcize the suggestion of death.

da Trivulzio" amounting to 3,046 ducats. In his will the general Gian Giacomo Trivulzio had left 4,000 ducats for a tomb and funerary monument to himself, to be built at the church of San Nazaro in Milan in the style of the unrealized Sforza statue, albeit on a smaller scale. Leonardo's note makes it possible to distinguish, among drawings made twenty years earlier for the Sforza Monument, a series of studies relating to the Trivulzio commission. Trivulzio, a marshal of France, had opposed Ludovico il Moro since 1488 and promoted his downfall. Leonardo's drawings, datable to 1508–11, show a horse and rider in various attitudes and designs for the tomb, one version of which includes columns with chained prisoners, as in Michelangelo's monument for Pope Julius II. Like so many of Leonardo's projects, this one was never executed.

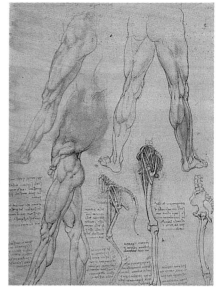

### Three-dimensional anatomy

During the winter of 1510 Leonardo made a new series of human anatomical studies, which represented a clear advance over his 1489 drawings. Working from dissections and precise, direct observation, he created sets of pictures of each object in the round, showing the phases of a progressive deconstruction of the human machine, with sectional views and sequences. For some drawings he removed certain parts or organs, the better to reveal the skeletal armature; for others he kept the musculature intact, in order to show its structure and constituent parts. In addition, he drew dissections of birds and other animals.

Visually, these plates—in which Leonardo's aesthetic and scientific concerns intersect—appear remarkably modern and formidably analytical. They number in the hundreds. Even the most grotesque images are beautiful, with fragments of mirror writing contributing to the artistic effect. Subjects are drawn from multiple

Marcantonio della Torre, a doctor of anatomy at the University of Pavia, made an important contribution to Leonardo's studies of anatomy. The doctor must have marveled at Leonardo's remarkable drawings of the limbs of men and horses (above) and of the branches of the respiratory and capillary systems, which Leonardo compared to trees and rivers.

viewpoints, presented in a logical, sequential, rhythmic, almost photographic manner. The incomparable descriptive skill of these studies surpasses all words: "The more detail you write," he commented, "the more you will confuse the mind of the hearer."

## From the Valtellina to Vaprio d'Adda

Leonardo studied the territory of Lombardy; as always, he was particularly interested in the water supply—the San Cristofano and Martesana canals, Lake Iseo, the Oglio River. At Vaprio on the Adda River he was a guest at the Villa Melzi, for which he designed

an extension. He mapped the environs of the towns of Bergamo and Brescia and the Valtellina and other alpine valleys as far as the Italian border. He measured the differences in level of the lakes around Brianza, seeking new, easier waterways between Milan and France via the Lambro River and Lake Como. He had bold ideas for dams and covered canals, even calculating possible future profits, as he had while planning the Arno River diversion. In the event, after 1516 King François I of France financed a project to render the Adda navigable; however, it was not completed until the end of the century.

The picture of the Vaprio ferry (above), which connects the city to Canonica across the Adda River, is extraordinary in both its simplicity and its accuracy, down to the least details.

## 1513: at the Vatican Belvedere

In 1511 Leonardo watched the fires set at Desio, outside Milan, by invading Swiss troops. Power was shifting once again in the Italian states. The following year the Swiss overthrew the French in Milan and put Massimiliano Sforza, the young son of Ludovico il Moro, on the throne. The French withdrew for good in September 1513. Despite his previous ties to the Sforza family, Leonardo was considered compromised by his service to the French. In Florence the Medici family returned, bringing to power the son of Lorenzo the Magnificent,

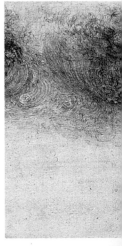

Piero de' Medici (a former ally of the French and friend of Leonardo); in March 1513 his brother Giovanni was elected pope, taking the name Leo X. Giuliano da Vinci, one of Leonardo's brothers, collaborated with painters such as Pontormo and Andrea del Sarto on designs for the grand festivities that Florence prepared in honor of the new pontiff. On 24 September Leonardo left Milan for Rome, together with his friends Francesco Melzi (1492–1570) and Salai, as well as a pupil named Lorenzo and someone he called "il Fanfoia."

His new patron was another brother of the pope, Giuliano de' Medici, called il Magnifico. As early as December he obtained for Leonardo a workshop at the Vatican—the sons of Lorenzo de' Medici seemed finally to be offering him the opportunities that their father had withheld thirty-two years earlier. Giuliano was a connoisseur of the arts and sciences and Rome in these heady days was a city of immense wealth, energy, and activity. Artists were flocking to the court of the Vatican. Leonardo again met the musician Atalante Migliorotti, now overseer of works at Saint Peter's, as well as many old friends, followers, and colleagues, including Bramante and Raphael. His rival Michelangelo was there, painting *The Flood* on the ceiling of the Sistine Chapel. Leonardo suffered his presence with difficulty: his ideas about painting and drawing natural phenomena, expressed at the time in notes on "How to Represent a Tempest" and "On a Deluge and the Representation of It in Painting," were based on a sense of symbolism and psychology altogether at odds with the younger man's.

### "Old junk" and innovations

Living in Rome, Leonardo was immersed in antiquity and mythology. He drew

An allegory of Falsehood is the theme of two sketches for a cameo (above). For Leonardo storms carry a heavy burden of symbolism: in *The Apocalyptic Tempest* (center) he expounds a "theory of catastrophes" that differs from the extremely mechanistic chaos of his other *Floods*. Amid trumpets, angels, and deities there resounds the fracas of cloudbursts; the fury of the elements rips trees out of the earth and throws riders to the ground; the unseated figures are tossed about like so many baby Hercules, while the figures on the right recall the infant twins who emerge squirming from *Leda*'s eggs.

the Vatican collection of antique Roman marbles; he described the ruins of the imperial temples and palaces and sketched the famous sculpture called the *Bocca della Verità* (the mouth of truth) on a sheet on which he also depicted, in the form of a cameo, allegories of Falsehood concealed by the sun of Truth. He is even credited with restoring *The Nile,* an ancient sculpture whose *putti* resemble those in *Leda and the Swan.*

He pursued inquiries into aesthetics and mechanics, the uses of compasses, designs for machines to mint coins, and the fossil shells found on Monte Mario, above the city.

His technical drawings—such as those for a crown-shaped wheel and for rope-braiding and metal-working machines—progressed, both in the quality

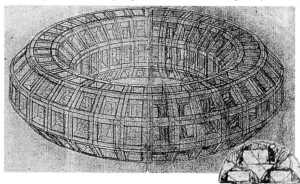

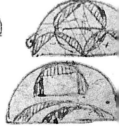

To depict this crown with 256 facets (left) Leonardo first drew half, then doubled the design by perforating the paper. His rope-making machine (above) has handsome decorative details. Below: three lunulas are drawn on a

of line and in the simplification of volumes and geometric shapes, almost to the point of abstraction.

## Geometric metamorphoses

On 7 July 1514 Leonardo found himself "at 23 o'clock" in his Vatican workshop, completing one of the geometrical games he loved. He studied lunulas (crescent shapes) and the properties of their surfaces; he tried to square the circle; he established correspondences between these questions of geometry and his study of the "transmuta-tions of metal bodies"—for example, the metamorphoses a substance undergoes in casting (he made tests with a wax pyramid, cube, and cylinder). The concept of

sheet with the remark: "The *medici* [doctors, Medici] created me and destroyed me." The art historian Kenneth Clark wrote, "Innumerable drawings...show us the nature of these geomet-rical games, and leave us

transformation fascinated him, whether it was the conversion of one kind of energy into another—say, hydraulic energy changed into wind energy by the action of a bellows—or the transformation of motor energy, perhaps from alternating into continuous movement, as with weight-lifting machines or those for polishing lenses. He determined the relationships between geometric transformations and mechanical laws and applied his studies of geometry to anatomy, for example, to the half-moon and three-pointed valves of the heart.

He had always had a taste for mathematical inventions. Within a drawing of a lunula, years earlier, he had written, "This invention was given me as a gift on Christmas morning, 1504." We may thus imagine Leonardo on a holiday morning—at a time when he was painting *The Battle of Anghiari* and planning the diversion of the Arno and as Isabella d'Este was pleading with him to paint for her—immersed in the study of arcs and triangles and the puzzle of squaring the circle. He thought he had managed this, noting in the *Codex Atlanticus:* "As I have shown, here at the side [indicating a diagram], various ways of squaring the circles, that is by forming squares of a capacity equal to the capacity of the circle, and have given the rules for proceeding to infinity, I now begin the book called 'De Ludo Geometrico.' " He was nonetheless aware that his solutions were approximations, infinitesimal calculations at the limit of "what the mind can imagine." His geometrical games were more than a mere pastime: they were an art of great abstraction.

## Games and toys

In a 1515 letter sent by a Florentine to Giuliano de' Medici Leonardo is cited as a paragon because he is a vegetarian, out of respect for animals. This did not keep him from carrying out dissections or, in Rome, indulging in

lamenting the waste of Leonardo's time and ingenuity. For these figures have as much to do with geometry as a crossword puzzle has to do with literature." Yet these games remind us that for Leonardo, as for artists of the 20th century, the relationship of art to science is often metaphorical. This wire-drawing machine (above) uses a turbine, an improvement over the mill systems then in use.

bizarre amusements and jokes, planned as he had planned masques and pageants at court. Vasari tells of a live lizard that Leonardo transformed into a miniature monster, dressing it in wings and horns made from the scales from other reptiles and painted with shiny mercury. On another occasion, collecting his audience into a room, he used concealed blacksmiths' bellows to inflate transparent animal gut until it filled all the available space, crowding the terrified viewers into a corner. He delighted in crafting not only grotesqueries but also charming conceits, such as light, delicate animal figures made of wax, which he caused to fly by blowing on them. For celebrations Leonardo devised outlandish costumes, fantastic machineries, and curious spectacles. He invented a poetics of wonder and astonishment, of brilliant, clever tricks. From elementary children's games to games of chance the artist observed even the simplest pastimes in order to extract from them essential principles applicable to architecture and science. A straw to blow soap bubbles, skipping stones that ricochet on water or form rings on the surface: these were the tools of deep research.

## Painting, architecture, wine-making, automatons

Leonardo was often away from the Vatican in the north. On 25 September 1514 he was in Parma, on the 27th on the banks of the Po River, probably as engineer to Giuliano de' Medici, captain general of the papal militia. On 8 October he returned to Rome, where he was elected to the Confraternity of San Giovanni dei Fiorentini (which he later quit). The Louvre's evocative painting of *Saint John the Baptist,* patron saint of the Florentines, dates to this period (see pages 110–11). Vasari records that he also painted a *Virgin and Child* and a portrait of a young man, though neither work has been identified. He designed improvements for the port of Civitavecchia and, in December 1514, a project to drain the malarial Pontine Marshes south of Rome. Visiting Florence, he designed stables and a new palace for the Medici and made suggestions for the renovation of their district of the city. In 1515 he invented a clockwork lion that was sent from Florence to Lyons as a coronation gift to the new French king, François I (r. 1515–47).

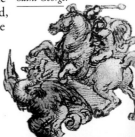

L eonardo studied the metamorphoses of cats into cockatrices and the fury of horses and dragons. Below: *Saint George.*

These fantastic animals (below) are among the grotesque figures and automatons that Leonardo employed for theatrical festivities. The lion sent by the city of Florence for the celebrations at Lyons in honor of François I was operated "by the power of the wheels," that is, presumably by gears. Struck three times by the king, it opened to reveal a blue interior decorated with fleurs-de-lis,

emblems of both the king of France and the city of Florence. The lion itself was a heraldic symbol from the coats of arms of both Lyons and Florence and also referred to the names of Pope Leo X and Leonardo himself.

In his notes he mentioned a determining event: "Giuliano de' Medici, il Magnifico, left Rome on the ninth day of January 1515, at daybreak, to take wife in Savoy. That very day there arrived the news of the death of the French king." Leonardo was in Bologna in December 1515 in the company of Giuliano to attend the meeting of Pope Leo X and François. Giuliano, who had been ill for some time, died shortly after, on 17 March 1516, leaving Leonardo without a patron.

He made a brief visit to Milan and wrote to the tenant farmer of a property he owned in Fiesole, near Florence, offering advice for improving the quality of the holding's wine. By 13 March 1516 he was once more in Rome,

This map (center) gives an aerial view of the Pontine Marshes and their towns: Circeo is at the bottom, Terracina on the right, and Sermoneta at upper left.

preoccupied with the solution of a mathematical problem; in August he was calculating the dimensions of the vast church of San Paolo Fuori le Mura there.

## "Mouths kill more people than knives do"

A series of notes for unsent letters to Giuliano de' Medici suggests that Leonardo was going through a period of crisis and exasperation. He complained of his German assistants, the mechanic Giorgio Tedesco and the mirror maker Giovanni, whom he accused of indiscretion and negligence and even of spying on him ("I cannot work in secret because of him"). The man spent hours dining with the Vatican's Swiss Guards and passed his days hunting in the ruins of ancient Rome; in short, he pursued only his own interests and worst of all had taken over Leonardo's studio space: "He has filled this whole Belvedere [the Vatican palace] with workshops for mirrors." An atmosphere of frustration and resentment developed. Slandered and accused of necromancy, Leonardo was barred from working at the Hospital of Santo Spirito and wrote: "[The German] hindered me in anatomy, blaming it before the Pope."

He was in his sixties and his health and eyesight were weakening. On a sheet covered with sketches of architecture and lunulas he wrote these mysterious words: "The *medici* created me and destroyed me." Was this a bitter summary of his relations with the Medici family or a play on the word *medici,* which simply means "doctors," whom he elsewhere calls "life-destroyers"? With Giuliano's death Leonardo made preparations to seek his fortune beyond the Alps.

### At the manor of Cloux and the court at Amboise

Late in 1516 Leonardo came to the court of France, where he had so often been invited. He was welcomed to Amboise on the Loire River, along with his companions Francesco Melzi and, perhaps, Salai. He was to pass the last years of his life at the royal manor of Cloux, close by the royal residence at Amboise, where Louis XII had established his court. In 1490 Charles VIII had acquired the manor and François de Valois, the future François I, had spent much of his childhood there. Upon his return

The manor of Cloux, near Amboise, has been known as Clos-Lucé since the 17th century (below: a 19th-century engraving). The view of the château of Amboise (bottom), a drawing kept with Leonardo's manuscripts at Windsor Castle, is by one of his students.

from Italy, Louis de Ligny—the king's cousin, whom Leonardo had named in his memorandum of 1499—had lived there. François was Leonardo's last patron; Cloux and Amboise proved to be neither exile nor an island of happiness, but rather a high circle of meetings and exchanges wherein he was a central figure. Other artists had preceded him there, such as Cristoforo Solario, a painter of his school, and the engineer Fra Giocondo, whom Leonardo had mentioned around 1508 in reference to an irrigation system for the garden at Blois.

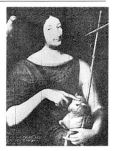

The memoirs of the Florentine sculptor Benvenuto Cellini, who later worked for François I, describe Leonardo at court—rather oddly mentioning his knowledge of classical languages and calling him a philosopher: "[Leonardo] having some knowledge of Latin and Greek letters, the King had fallen in love with his great abilities and took such pleasure in listening to his converse that he spent several days a year with him."

### Allegories and celebrations

In France Leonardo resumed his theatrical activities and revised a few of his more fantastic set pieces, such as the mechanical lion. This was revived for the Feast of Paradise at Cloux in François's honor on 17 June and again the following year for his ceremonial entry into Argentan on 30 September 1517 with his aunt, the duchess Philiberta, Giuliano de' Medici's widow.

Leonardo had become paralyzed in the right arm, but being left-handed was not greatly hampered. He contin-

Above: François I at the age of twenty-four, according to the inscription, portrayed as Saint John in the style of Leonardo. This painting was rediscovered in the last century and at the time was considered a "priceless, sublime, and unique painting, certainly the last by the royal father of art, Leonardo da Vinci." At Amboise Leonardo received a pension of 2,000 écus for two years; Melzi received 800 and Salai only 100.

ued to labor in his workshop at Cloux and in May 1518 contributed to the festivities given at Amboise for the birth of François's son and for the marriage of Lorenzo de' Medici to Madeleine de La Tour d'Auvergne, the king's niece. He fashioned a triumphal arch featuring the royal emblems, the salamander and the ermine, and his own Latin device: *Potius mori quam foedari,* "better to die than to be soiled."

## An ideal city

François, though still young, was already proving himself a great patron of arts and letters. Leonardo's title at Amboise was "first painter" and "engineer and architect of the king" and he now began to develop a vast plan for a new city called Romorantin. Its geometric layout resembled that of a Roman *castrum,* or military town—the name "Romolontino," as Leonardo wrote it, derived from the town of Roma Minor that Julius Caesar had built on the Sauldre River, a tributary of the Loire that legend compared to the Tiber. The setting was well worthy of an imperial plan.

The plan proposed by Leonardo was rigorous, conceptual, and modern: a central canal on two levels acted as the principal axis; on either side of it, laid out in a regular grid, were streets, bridges, buildings, and squares. The urban plan culminated in "the palace of the prince." It had fountains, kitchens, and stables. "Houses intended for dancing," he noted, "must be on the ground-floor; for I have already witnessed the destruction of some, causing death to many persons." He included an immense basin for naumachias, miniature mock naval battles, and "water tournaments with ships," popular at Renaissance courts.

Work on this ideal city began, but the declining state of Leonardo's health kept him away from the site and before long an epidemic obliged François to transfer his projects to the château of Chambord, farther up the Loire valley. Leonardo's contribution to this splendid château's construction seems confirmed by a note of 1518 in which he mentions a certain Master Domenico Barnabei da Cortona, believed to be one of the architects of Chambord, and by his sketches of double staircases,

Leonardo was the official "mechanic" at court. For royal celebrations he created sets and the machines to make them; and though he rebelled against the tyranny of fashion, he designed splendid, sometimes extravagantly graceful costumes (above). Right: the studies for Romorantin include panoramic views and maps such as this one with central- and octagonal-plan buildings, a royal palace, and a pool for staging mock naval battles.

square-plan rooms, cruciform halls, and central-plan châteaus that look like monumental villas. Tradition has it too that the châteaus built by Florimond Robertet at Bury and by Georges d'Amboise at Gaillon reflect Leonardo's architectural ideas, since he had known both men in Italy.

## Twilight

At Amboise Leonardo became interested in the Île d'Or, an island in the Loire, and as usual investigated hydraulic systems for the river. On 10 October 1517 he was visited at Cloux by Cardinal Louis d'Aragon, whose secretary, Don Antonio de Beatis, made fascinating notes in his *Itinerario* that are one of the last records we have of Leonardo. He recorded the paralysis of the artist's arm and remarked that the elderly master could no longer "color with the sweetness that was his custom," but was still "making drawings" and teaching. "He has trained a Milanese

Leonardo thought to find the inhabitants of the new city of Romorantin (below) in Villefranche, a few kilometers away. The elderly artist turned his spirit of observation and invention to wooden architecture: he conceived the idea of transporting homes from Villefranche to Romorantin. "This will be easily done," he wrote, "because the houses have been built in pieces earlier"—a phrase that has often been cited to support the claim that Leonardo invented the first prefabricated houses. He also planned to divert the course of the river to create a "navigable canal for purposes of commerce" and described a method for cleaning the riverbed with the dams of river mills, recalling the "movable sluices" that he had had built in Friuli in 1500.

student who works fairly well." (This was the young Francesco Melzi.) The secretary praised Leonardo's manuscripts, observing that if they should appear in print their number and importance would be seen. And indeed, the artist was beginning to consider publishing them and even pondered the typography and layout that would best suit. Like so many of his good ideas, this was not carried out. Taken to Italy by Melzi after his death, the manuscripts were dispersed by Melzi's son. They were offered to the Grand Duke of Tuscany, whose advisers called them "hackneyed things" and convinced him not to buy them.

### *Perfectissimi:* painting at Cloux

Leonardo showed Cardinal d'Aragon three finished paintings, which Don Antonio recorded as *"perfectissimi,"* entirely perfect. It is believed that the first, which represented "a certain Florentine lady, done *au naturel,* at the request of the magnificent Giuliano de' Medici," is the *Mona Lisa* (or possibly a lost *Nude Gioconda* or *Monna Vanna*). The second, referred to as "San Johanne Baptista jovene," is assumed to be the Louvre's *Saint John the Baptist,* although the word *jovene,* "young," raises a few doubts. From the evidence, the third would seem to be *The Virgin and Child with Saint Anne,* which, being unfinished, was perhaps not *perfectissima.* Its ethereal, metaphysical landscape is surely Leonardo's last work in this vein. The exquisitely detailed gravel at

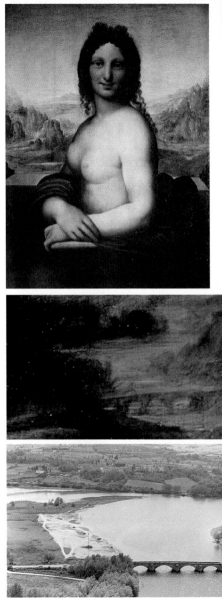

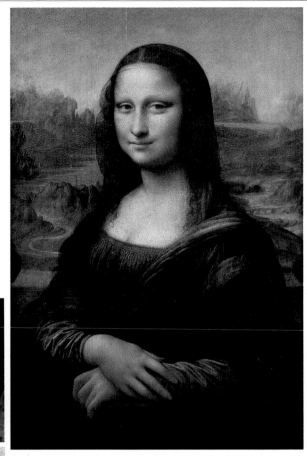

the figures' feet displays Leonardo's advanced aesthetic and pictorial ideas, in which poetic artifice merges easily with an accurate, naturalistic account of geology.

Vasari tells us that François I invited Leonardo to France especially to "paint the cartoon of St. Anne." This is a valuable clue in dating the work, as is the comment by the Italian biographer Paolo Giovio, written between 1523 and 1527, that there "remained a painting on wood [by Leonardo] showing a Christ Child playing with the Virgin his mother and his grandmother Anne, which

The identity of Mona Lisa, probably painted in Florence around 1503, is a mystery. In Italian she is known as *La Gioconda,* "the merry one," referring to her subtle smile and possibly a play on the name of the sitter, who may have been a certain Lisa Gherardini del Giocondo. An early biographer maintained that Leonardo "painted the portrait of Piero Francesco del Giocondo," not his wife. Other hypotheses have been proposed, some absurd (a self-portrait as a woman?). Among the paintings listed as inherited by Salai was a *Gioconda* by an unknown artist. In the work both figure and landscape are idealized, though the bridge is often identified as that of Buriano, near Arezzo (details opposite). Leonardo made a related drawing, copied by Raphael around 1505 (above). There was also a *Nude Gioconda,* known only through versions by Leonardo's followers (opposite, above) and a cartoon.

François, king of France, purchased and placed in his chapel." After that there is no trace of the painting in the royal collections before 1629, when Cardinal Richelieu offered it to Louis XIII, after finding it in Piedmont. In 1525, among the goods left by Salai following his marriage and his "violent death," a *Saint Anne* was appraised at 100 écus, as was a *Gioconda*.

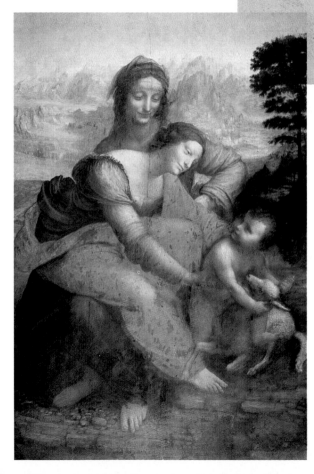

A mong Leonardo's last drawings is an unfinished study of the robes of the Virgin (above). Freud and other psychoanalysts have misread the image and mistakenly interpreted it as an encoded representation of a memory of a vulture from Leonardo's childhood. Left: several different compositional schemas are integrated in the Louvre's *Virgin and Child with Saint Anne*. In the foreground the figures form a pyramidal structure comprising a series of curvilinear volumes. Their gazes are a network of intersecting lines. The light is lunar and motionless, so that the scene occurs in a metaphysically atemporal space. The remote, vertiginous landscape is a living organism, detached from the human events of the foreground, infinite and silent.

Did the student bring his teacher's masterpieces back to Italy? Other sources recount that François I purchased the *Mona Lisa* for 4,000 écus. In his will of 23 April 1519, however, Leonardo wrote that all "the instruments and portraits appertaining to his art and calling as a painter" were to go to Melzi, not Salai. The word *portracti* most likely refers to his paintings as a whole.

"When I thought I was learning to live, I was learning to die," wrote Leonardo. The most famous representation of his death (below) is Ingres's 1818 painting, which repeats the tale that the king was present.

Leonardo died at Cloux on 2 May 1519. Although François I was far away in his château at Saint-Germain-en-Laye, Vasari completes the artist's legend by stating that he "breathed his last in the arms of the king."

Little about Leonardo is known for certain; everything contributes to his myth. But an artist of such unique attributes cannot be defined according to ordinary criteria. Leaving aside the innumerable interpretive approaches his vast and various work permits, his radical originality, the freedom of his art, and the power of his images create the timeless immediacy of his oeuvre.

Overleaf: Leonardo between Dürer and Titian in a detail of a little-known painting, one of a series on illustrious men, from the school of Bronzino.

# DOCUMENTS

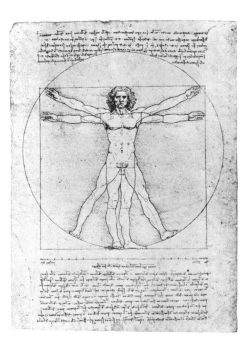

Leonardo da Vinci, deep mirror of darkness,
Where angels appear, their smiles charged with mystery
And tenderness, within the shadowy enclosures
Of pines and glaciers that shut in their country.

   Charles Baudelaire, "Beacons," *The Flowers of Evil,*
   1868, translated by David Paul

# Portraits of a mysterious man

*Who is Leonardo? Our information on this almost mythic personality comes partly from his own writings and partly from the observations of his contemporaries. His works of art bear another sort of witness.*

## Leonardo's biographers

*Leonardo revealed little about himself, even in his private notes, but biographers over the centuries have not been lacking. One of the first, a chronicler known as the Anonimo Gaddiano, wrote a description of him a few years after the artist's death.*

Leonardo da Vinci, citizen of Florence, although not born legitimate, was the son of Ser Piero da Vinci and was born of a mother of good blood. He was so rare and universal a man that one could say he was a product of both nature and miracle—not only because of his physical beauty, which was well-acknowledged, but also by virtue of the many rare talents of which he was master. He was skilled in mathematics and no less in perspective, and he made sculptures and far surpassed all others in drawing. He had wonderful ideas, but he did not paint many of them, because, they say, he was never himself satisfied, and thus his works are few. He was most eloquent in speech, and played the lyre well.…He enjoyed the company of the common people and was extremely good at making waterworks and fountains and other caprices, nor was his spirit ever still, but always engaged in cleverly devising new things.…

He was a beautiful man, well-

Raphael, who knew him, is said to have given Leonardo's face to the figure of Plato (left) in his great Vatican fresco *The School of Athens;* the sage is shown pointing to the heavens in a gesture that echoes figures in Leonardo's *Saint John the Baptist* (pages 110–11) and *The Last Supper* (page 78). Thus Leonardo becomes the embodiment of classical philosophy, the wise man who inquires into the form and meaning of all things. The artist himself was probably in closer sympathy with the investigative mind and method of Aristotle than with Plato.

proportioned, graceful, and of handsome aspect. He wore a pink, knee-length robe, though at the time long robes were worn: he had beautiful hair, which came down to mid-breast, curled and well combed.

Anonimo Gaddiano, *Codex Magliabecchiano*, c. 1530

*Paolo Giovio (1483–1552) wrote one of the earliest biographies of Leonardo, a brief account in Latin. Himself a physician, Giovio was interested in Leonardo's scientific method and especially in the dissections he performed, at that time an unusual—and not quite legal—act.*

Leonardo, born at Vinci, an insignificant hamlet in Tuscany, has added great lustre to the art of painting. He laid down that all proper practice of this art should be preceded by a training in the sciences and the liberal arts which he regarded as indispensable and subservient to painting. He placed modelling as a means of rendering figures in relief on a flat surface before other processes done with the brush. The science of optics was to him of paramount importance and on it he founded the principles of the distribution of light and shade down to the most minute details. In order that he might be able to paint the various joints and muscles as they bend and stretch according to the laws of nature he dissected the corpses of criminals in the medical schools, indifferent to this inhuman and disgusting work. He then tabulated all the different parts down to the smallest veins and the composition of the bones with extreme accuracy in order that this work on which he had spent so many years should be published from copper engravings for

the benefit of art. But while he was thus spending his time in the close research of subordinate branches of his art he only carried a few works to completion; for owing to his masterly facility and the fastidiousness of his nature he discarded works he had already begun. … His charm of disposition, his brilliancy and generosity was not less than the beauty of his appearance. His genius for invention was astounding, and he was the arbiter of all questions relating to beauty and elegance, especially in pageantry. He sang beautifully to his own accompaniment on the lyre to the delight of the entire court. He died in France at the age of sixty-seven to the grief of his friends.

Paolo Giovio, *Leonardi Vincii Vita,* c. 1527, translated by Jean Paul Richter

*The Italian painter, biographer, and art historian Giorgio Vasari (1511–74) remains a principal Renaissance source on Leonardo, though he wrote some thirty years after the master's death and some of his reporting is based on hearsay.*

Many men and women are born with various remarkable qualities and talents; but occasionally, in a way that transcends nature, a single person is marvellously endowed by heaven with beauty, grace, and talent in such abundance that he leaves other men far behind, all his actions seem inspired, and indeed everything he does clearly comes from God rather than from human art.

Everyone acknowledged that this was true of Leonardo da Vinci, an artist of outstanding physical beauty who displayed infinite grace in everything he did and who cultivated his genius so brilliantly that all problems he studied he solved with ease. He possessed great

strength and dexterity; he was a man of regal spirit and tremendous breadth of mind; and his name became so famous that not only was he esteemed during his lifetime but his reputation endured and became even greater after his death.

Giorgio Vasari, *Lives of the Artists,* rev. ed., 1568, translated by George Bull

*The chronicler Giovan Paolo Lomazzo (1538–1600) wrote a book on aesthetics and the practice of painting in which he praises Leonardo, whose mythic reputation here assumes a Merlinesque presence.*

He had a face with long hair and with brows and a beard so long that he appeared the very image of lofty thought, as were in olden times the druid [i.e., god] Hermes or ancient Prometheus.

Leonardo expresses nobility of soul; dexterity; clarity of imagination; wisdom in thinking, understanding, and execution; mature intelligence conjoined with beauty of face; justice; reason;

judgment; the division of righteous from unjust things; the loftiness of light; the depth of the shadows of ignorance; the profound glory of truth; and that charity is the queen of all virtues.

Giovan Paolo Lomazzo, *The Idea of the Temple of Painting,* 1590

*Sabba da Castiglione (1480–1554), a cleric who published a memoir in Venice in the mid-16th century, recalled the destruction of Leonardo's scale model of the equestrian statue:*

[Leonardo] was working on the model of the horse in Milan, which for sixteen years continued to consume him; and the dignity of the work was such that one certainly couldn't call it a waste of time and effort. But some people, ignorant and neglectful, who because they do not recognize excellence do not value it, most disgracefully let [the statue] fall to ruin; and I recall—and not without pain and sorrow I say it—that so noble and ingenious a work was used for target practice by Gascon crossbowmen.

Sabba da Castiglione, *Memoirs,* 1559

*Some modern biographers have analyzed not only Leonardo himself, but the impact of his legend on modern culture.*

While for the nineteenth century Leonardo was in various ways viewed as the heroic harbinger of the modern condition, our reading of him today is far different. He belongs to another age that seems increasingly distant from ours....

The one thing that seems certain is that there are new Leonardos yet to be born, for undefinable contingencies and impenetrable silences spur the ongoing project of interpretation. It is safe to say that there will be no interpretive closure, for that would be both an affront to the

"Self-portrait" of Leonardo at forty: this is the outline of his shadow in a window, projected against a wall.

needs of the imagination and a denial of the truism that with new times inevitably come new questions.

A. Richard Turner,
*Inventing Leonardo,* 1992

*The pioneering Renaissance political philosopher Niccolò Machiavelli (1469–1527) knew Leonardo. Just how much these two visionary thinkers influenced each other is a question recently explored by a modern scholar.*

Neither Machiavelli nor Leonardo mentions the other by name in writings or letters that have survived; this is not conclusive, however, since both were legendary for their elusiveness or deviousness.... Letters and archival materials prove that between 1503 and 1506 Machiavelli's responsibilities included four projects on which Leonardo da Vinci was involved. One of these, an attempt to divert the Arno River during the siege of Pisa, is especially important: a letter from the field proves that Leonardo visited the site on 23 July 1503 and played a role in the adoption of the project. Machiavelli's dispatches from Florence demonstrate that he took an active role in supervising the attempted diversion.... This experience had a lasting impact on Machiavelli, whose writings echo views of science, warfare, and technology found only in Leonardo's *Notebooks.* This influence is of the greatest importance because Leonardo himself had worked out visionary plans for a political system that foreshadowed modern industrial societies....

Leonardo's life and work were focused on radical innovations, everywhere challenging the distinction between theory and practice inherited

In this painting Leonardo is shown between Titian, the great representative of Venetian painting, and Albrecht Dürer, the "Leonardo of the North." Traveling in Italy, Dürer wrote that he planned to go from Venice to Bologna in October 1508 "to learn the secrets of the art of perspective, which a man there is willing to teach me." Would it be too romantic to imagine a meeting with Leonardo?

from the past. In domains as diverse as painting, mathematics, physics, hydraulics, military engineering, architecture, and comparative anatomy, Leonardo introduced concepts and practices often centuries before they were fully realized in the West. More to the point, Leonardo extended these concepts to the study of human nature, society, and law, foreseeing a modern community based on private property and scientific technology.

These developments help explain why Machiavelli would have been influenced by his encounter with Leonardo. Whether the two men were once close friends or merely contemporaries whose direct contact was limited to consultations on official projects, their work can be said to symbolize the origins of modernity.

Roger D. Masters, *Machiavelli, Leonardo, and the Science of Power,* 1996

# Freud and Leonardo

*Among the most famous—and peculiar—of Sigmund Freud's psychoanalytic case studies is his attempt to explore the persona of Leonardo, a man who had died some 400 years earlier. His essay was based not on therapeutic interviews with the subject, but on an examination of the artist's surviving note-books and paintings. How much can we deduce about a man from the records he leaves? How much can an artist's work reveal his temperament? Much in this essay has been discredited; perhaps it tells us more about its author than about Leonardo. "He was like a man who wakes too soon in the darkness, while others are still sleeping," wrote Freud.*

Anamorphic drawing of a child's face.

*In the* Codex Atlanticus *Leonardo recalled a childhood memory: "In the earliest recollections of my infancy it seemed to me when I was in the cradle that a kite [a bird] came and opened my mouth with its tail, and struck me within upon the lips with its tail many times." Freud saw this account as highly symbolic and revealing and took it as a clue to Leonardo's sexuality and thus to his psyche. In this passage he considers Leonardo's passion for knowledge as it might have affected his happiness in life.*

Because of his insatiable and indefatigable thirst for knowledge, Leonardo has been called the Italian Faust.…The postponement of loving until full knowledge is acquired ends in a substitution of the latter for the former. A man who has won his way to a state of knowledge cannot properly be said to love and hate; he remains beyond love and hatred. He has investigated instead of loving. And that is perhaps why Leonardo's life was so much poorer in love than that of other great men, and of other artists. The stormy passions of a nature that inspires and consumes, passions in which other men have enjoyed their richest experience, appear not to have touched him. There are some further consequences. Investigating has taken the place of acting and creating as well. A man who has begun to have an inkling of the grandeur of the universe with all its complexities and its laws readily forgets his own insignificant self.

*At a later point Freud associates the genius of the artist with sexual passion and suggests that his portraits of women reveal something of his feelings for his mother.*

Leonardo emerges from the obscurity of his boyhood as an artist, a painter and a

sculptor, owing to a specific talent which may have been reinforced by the precocious awakening in the first years of childhood of his scopophilic instinct.... We must emphasize the fact…that what an artist creates provides at the same time an outlet for his sexual desire; and in Leonardo's case we can point to the information which comes from Vasari, that heads of laughing women and beautiful boys—in other words, representations of his sexual objects—were notable among his first artistic endeavours. In the bloom of his youth Leonardo appears at first to have worked without inhibition....

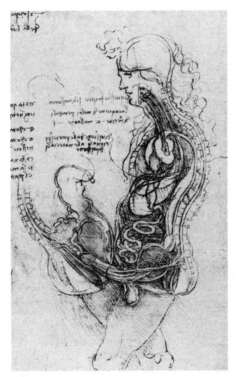

<small>A</small>natomical study of standing coitus.

becoming stunted. He met the woman who awakened his memory of his mother's happy smile of sensual rapture; and, influenced by this revived memory, he recovered the stimulus that guided him at the beginning of his artistic endeavours, at the time when he modelled the smiling women. He painted the Mona Lisa, the "St. Anne with Two Others" and the series of mysterious pictures which are characterized by the enigmatic smile. With the help of the oldest of all his erotic impulses he enjoyed the triumph of once more conquering the inhibition in his art. This final development is obscured from our eyes in the shadows of approaching age. Before this his intellect had soared upwards to the highest realizations of a conception of the world that left his epoch far behind it.

At the summit of his life, when he was in his early fifties…a new transformation came over him. Still deeper layers of the contents of his mind became active once more; but this further regression was to the benefit of his art, which was in the process of

Sigmund Freud, *Leonardo da Vinci and a Memory of His Childhood*, 1910, translated by Alan Tyson

# Leonardo in his own words

*Although some 7,500 pages of Leonardo's notebooks survive, he is reticent about his personal affairs. Nevertheless, his manuscripts taken as a whole present a self-portrait of sorts. He sometimes referred to himself in the third person, writing, for example, to the overseers of the cathedral of Piacenza: "There is no capable man—and you may believe me—except Leonardo the Florentine"* (Codex Atlanticus).

A list of Leonardo's expenses on a sheet of the *Codex Arundel.*

## Leonardo on the artist's temperament and good working habits

Many are they who have a taste and love for drawing, but no talent; and this will be discernible in boys who are not diligent and never finish their drawings with shading (*Manuscript G*). A painter needs such mathematics as belong to painting. And the absence of all companions who are alienated from his studies; his brain must be easily impressed by the variety of objects, which successively come before him, and also free from other cares. And if, when considering and defining one subject, a second subject intervenes—as happens when an object occupies the mind, then he must decide which of these cases is the more difficult to work out, and follow that up until it becomes quite clear, and then work out the explanation of the other. And above all he must keep his mind as clear as the surface of a mirror, which assumes colours as various as those of the different objects. And his companions should be like him as to their studies, and if such cannot be found he should keep his speculations to himself alone, so that at last he will find no more useful company [than his own] (*Codex Atlanticus*).

To the end that well-being of the body may not injure that of the mind, the painter or draughtsman must remain solitary, and particularly when intent on those studies and reflections which will constantly rise up before his eye, giving materials to be well stored in the memory. While you are alone you are entirely your own [master] and if you have one companion you are but half your own....And if you have many companions you will fall deeper into

the same trouble. If you should say: "I will go my own way and withdraw apart, the better to study the forms of natural objects," I tell you, you will not be able to help often listening to their chatter. And so, since one cannot serve two masters, you will badly fill the part of a companion, and carry out your studies of art even worse. And if you say: "I will withdraw so far that their words cannot reach me and they cannot disturb me," I can tell you that you will be thought mad. But, you see, you will at any rate be alone. And if you must have companionship find it in your studio. All other company may be highly mischievous (*Manuscript B1*).

## On beauty

Do you not see that, among human beauties, it is a very beautiful face and not rich ornaments that stops passers-by?…Do you not see beautiful young people diminish their excellence with excessive ornamentation?…Do not paint affected curls or hair-dressings such as are worn by fools fearful that a single, misplaced lock will bring disgrace upon them.…Such people have the mirror and comb for their advisors, and the wind that disarranges their carefully dressed hair is their main enemy.

Depict hair which an imaginary wind causes to play about youthful faces, and adorn heads you paint with curling locks of various kinds. Do not do like those who plaster their hair with glue and make their faces appear as if turned to glass, [and pursue] ever greater follies, [such as using the] gum arabic that sailors bring from the East to prevent the wind from stirring their ringlets (*Treatise on Painting*).

Note in the streets, as evening falls, the faces of the men and women, and

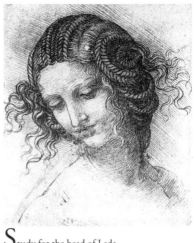

Study for the head of Leda.

when the weather is dull, what softness and delicacy you may perceive in them. Hence, Oh Painter! [work in] a court[yard] arranged with the walls tinted black…and covered with a linen awning; or else paint a work towards evening or when it is cloudy or misty, and this is a perfect light (*Manuscript B1*).

If [the soul] finds somebody who resembles the body that it has composed, it likes that person and often falls in love. For this reason, many fall in love and marry women who look like themselves.…Note the beautiful parts of a great number of beautiful faces, whose beauty is confirmed by the general opinion, rather than by your own judgment, for you might make the mistake of choosing faces that look like yours. It happens, indeed, that we love what resembles us; if you are ugly, you will choose faces without beauty and you will make them ugly as do many painters whose figures resemble their maker (*Treatise on Painting*).

## On logic and creativity

Movement is said to have two natures because it is made of different powers; in fact, it falls into two parts, of which one is spiritual and the other material. What is spiritual in us is made of the power of the imagination; what is material is made of the material bodies (*Madrid Manuscript I*). Experience is never at fault; it is only your judgment that is in error in promising itself such results from experience as are not caused by our experiments (*Codex Atlanticus*).

Although nature commences with reason and ends in experience it is necessary for us to do the opposite, that is to commence ... with experience and from this to proceed to investigate the reason (*Manuscript E*).

## On the cave of knowledge

*Leonardo's passion for knowledge encompassed a desire to understand himself. His notes thus reveal his personality.*

Urged by an ardent desire, anxious to see the abundance of the various strange forms that nature the artificer creates, having traveled a certain distance between overhanging rocks, I arrived at the orifice of a great cave.... Two emotions suddenly awoke in me: fear and desire; fear of the dark menacing cave, desire to see if it hid some wonder (*Codex Arundel*). If liberty is dear to you, may you never discover that my face is love's prison (*Codex Forster III*).

This old man, a few hours before his death, told me that he had lived a hundred years, and that he did not feel any bodily ailment other than weakness, and thus while sitting upon a bed in the hospital of Santa Maria Nuova at Florence, without any movement or sign of anything amiss, he passed away from this life. And I made an autopsy in order to ascertain the cause of so peaceful a death....The other autopsy was on a child of two years, and here I found everything the contrary to what it was in the case of the old man (*Windsor Castle Royal Library*).

## On the painter in his workshop

[The sculptor's work] is a most mechanical exercise accompanied many times with a great deal of sweat, which combines with dust and turns into mud. The sculptor's face is covered with paste and all powdered with marble dust, so that he looks like a baker, and he is covered with minute chips, so that he looks as though he had been out in the snow. His house is dirty and filled with chips and dust of stone. In speaking of excellent painters and sculptors we may say that just the opposite happens to the painter, since the well-dressed painter sits at great ease in front of his work, and moves a very light brush, which bears attractive colors, and he is adorned with such garments as he pleases. His dwelling is full of fine paintings and is clean and often filled with music, or the sound of different beautiful works being read, which are often heard with great pleasure, unmixed with the pounding of hammers or other noises (*Treatise on Painting*).

## On art history

*Leonardo's statements on representing the real and imitating nature should not be seen as a theory of realism or a reductive naturalism. Rather, one turns to nature to understand and to practice its perfect and divine creative method.*

The painter will produce pictures of small merit if he takes for his standard the pictures of others. But if he will study from natural objects he will bear good fruit; as was seen in the painters after the Romans who always imitated each other and so their art constantly declined from age to age. After these came Giotto the Florentine who—not content with imitating the works of Cimabue his master—…began by drawing on the rocks the movements of the goats of which he was keeper.… After much study he excelled not only all the masters of his time but all those of many bygone ages. Afterwards this art declined again, because everyone imitated the pictures that were already done; thus it went on from century to century until Tomaso, of Florence, nicknamed Masaccio, showed by his perfect works how those who take for their standard any one but nature—the mistress of all masters—weary themselves in vain (*Codex Atlanticus*).

### On sex

*Leonardo was scornful of sexual urges, especially those moments in which the mind allows itself to be overruled by the body.*

He who does not restrain his lustful appetites places himself on the same level as the beasts (*Manuscript H*). The act of coupling and the members engaged in it are so ugly that if it were not for the faces and adornments of the actors, and the impulses sustained, the human race would die out (*Manuscript A*).

*On the other hand, he saw sex as an aspect of human anatomy, a legitimate and natural subject of scientific study. In this respect, he was a forerunner of the Enlightenment. The penis, he observed,*

has dealings with human intelligence and sometimes displays an intelligence of its own; where a man may desire it to be stimulated, it remains obstinate and follows its own course; and sometimes it moves on its own without permission or any thought by its owner. Whether one is awake or asleep, it does what it pleases; often the man is asleep and it is awake; often the man is awake and it is asleep; or the man would like it to be in action but it refuses; often it desires action and the man forbids it. That is why it seems that this creature often has a life and an intelligence separate from that of the man, and it seems that man is wrong to be ashamed of giving it a name or showing it; that

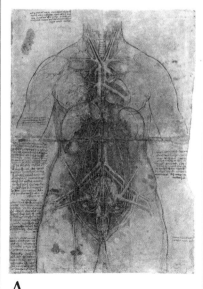

Anatomical study of a woman's body.

which he seeks to cover and hide he ought to expose solemnly like a priest at mass (*Manuscript B*).

*Elsewhere he made notes on the structure and dilations of the vulva, which he humorously referred to as "the gatekeeper of the fortress." He was fond of jokes and tales of all sorts and recorded several that are typically ribald in the Renaissance manner. Studying female genitalia, he noted:*

In general, woman's desire is the opposite of man's. She wishes the size of the man's member to be as large as possible, while the man desires the opposite for the woman's genital parts, so that neither ever attains what is desired (*Windsor Castle Royal Library*).

## On the power of painting

The eye, which is called the window of the soul, is the principal means by which the central sense can most completely and abundantly appreciate the infinite works of nature; and the ear is the second, which acquires dignity by hearing of the things the eye has seen. If you, historians, or poets, or mathematicians had not seen things with your eyes you could not report of them in writing. And if you, O poet, tell a story with your pen, the painter with his brush can tell it more easily, with simpler completeness and less tedious to be understood....Though the poet is as free as the painter in the invention of his fictions they are not so satisfactory to men as paintings; for, though poetry is able to describe forms, actions and places in words, the painter deals with the actual similitude of the forms, in order to represent them. Now tell me which is the nearer to

the actual man: the name of man or the image of the man. The name of man differs in different countries, but his form is never changed but by death (*Manuscript A1*).

## On food and the food chain

*Leonardo the vegetarian, Leonardo the health expert: his manuscripts contain medical recipes and designs for automated kitchens. Jotted on drawings for* Leda and the Swan *and other studies are shopping lists: wine and bread, eggs and mush-rooms, soup and salad, but also meat and chicken.*

Man and the animals are merely a passage and channel for food, a tomb for other animals, a haven for the dead, giving life by the death of others, a coffer full of corruption (*Codex Atlanticus*). [Men who boast but do

In among these delightful sketches of twenty-seven cats is one rather feline little dragon.

nothing] can call themselves nothing more than a passage for food, producers of dung, fillers up of privies, for of them nothing else appears in the world (*Codex Forster II*). Men shall come forth out of graves changed to winged creatures [i.e., flies that feed on corpses] and they shall attack other men, taking away their food even from their hands and tables (*Manuscript I*).

## Cruelty to animals breeds barbarity

*In his* Prophecies *Leonardo waxed indignant about human cruelty to animals, and even to plants:*

Of sheep, cows, goats and the like: from countless numbers will be stolen their little children, and the throats of these shall be cut, and they shall be quartered most barbarously (*Codex Forster II*). Of eggs which being eaten cannot produce chickens: Oh! how many will those be who will never be born (*Codex Atlanticus*). Of nuts, olives, acorns, chestnuts, and the like: many children shall be torn with pitiless beatings out of the very arms of their mothers, and flung upon the ground and then maimed (*Codex Atlanticus*).

## Health and medicine

*Despite his incomparable anatomical drawings, Leonardo remained distant from the practice and language of medicine. His notes and letters are studded with somewhat simplistic—and sometimes contradictory—comments:*

Just as for the doctors, the tutors and guardians of the sick, it is necessary that

$S$tudy of a skull.

they should understand what man is, what life is, and what health is, and how a parity or harmony of elements maintains this, and in like manner a discord of these ruins and destroys it; …medicines when well used restore health to the sick (*Codex Atlanticus*). Just as eating contrary to the inclination is injurious to the health, so study without desire spoils the memory, and it retains nothing that it takes in (*Manuscript A1*).

*Also in the* Codex Atlanticus *is a rhymed verse of practical medical advice of the sort popular since ancient times. Among Leonardo's books there is mentioned a* Treatise on the Preservation of Health, *but one wonders if it was no more scientific than this doggerel:*

If you would keep healthy, follow this regimen: do not eat unless you feel inclined, and sup lightly; chew well, and let what you take be well-cooked and simple. He who takes medicine does himself harm; do not give way to anger and avoid close air; hold yourself upright when you rise from table and do not let yourself sleep at midday. Be temperate with wine, take a little frequently, but not at other than the proper meal-times, nor on an empty stomach; neither protract nor delay the [visit to] the privy. When you take exercise let it be moderate. Do not remain with the belly recumbent and the head lowered, and see that you are well covered at night. Rest your head and keep your mind cheerful; shun wantonness, and pay attention to diet.

# Leonardo's science

*Studying hydraulics, engineering, mechanics, physics, astronomy, optics, and anatomy Leonardo was as much scientist as artist. He was that rare thinker: both practical fabricator and theoretician. He envisioned machines centuries ahead of their time: a helicopter, a multibarreled automatic gun, a submarine, a diving suit, an automobile, an armored car, a crank elevator, a hydraulic saw, a water clock, a bicycle. As a visionary inventor he is without precedent; as a scientific and technical draftsman he is without peer.*

## Machines

*Leonardo designed instruments for measuring wind velocity and air humidity, a slope meter for air navigation, machines for cutting the threads on screws and making springs, and refined ratchet gears, cog wheels, and pulleys. He made detailed notes on*

the nature of the screw and of its use, and how it should be used to pull rather than to push; and how it is stronger if it is single rather than double, and thin rather than thick…and how many kinds of never-ending [i.e., perpetual] screws can be made and how the never-ending screw can be paired with cog wheels (*Madrid Manuscript I*).

## Weapons

*Between 1480 and 1490 Leonardo was much occupied in designing firearms: tinderboxes with fuses or flints with spiral springs; a firelock that sprayed bullets in a fan pattern, with several racks that*

Bombards firing shrapnel shells.

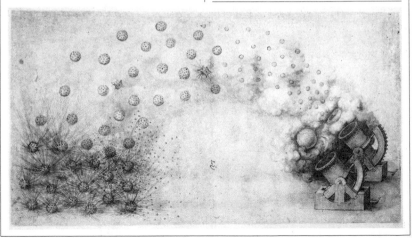

*turned to increase the speed and number of shots; naval cannon; a pivoting caisson mortar; and a* circumfolgore, *a revolving circular platform mounted with cannon. To many of these he gave fanciful names: the* alcimandre, alobrot, arcab, attanasses, bricola, carcaflotiles, clirp, clot, frolisto, imilcrone, martilatro, stringula, *and the aforesaid* circumfolgore. *And let us not forget the* architronito, *a steam-powered cannon whose name refers to thunder. He was enthusiastic about three of its most spectacular effects: smoke, fury, and vibrations. The* cotombrot *was a*

cannonball a half foot wide, full of small projectiles made of paper mixed with sulfur, pitch, and "conocarsico," which makes one sneeze when sniffed and in the middle there is gunpowder which when lit sets fire to all of the projectiles, and before [that] it is thrown among the troops with a wick tied with a pouch and then the rockets scatter themselves over an area a hundred armlengths in diameter and whistle (*Manuscript B*). [The large mortar] is the most deadly machine that exists. And when the cannonball falls the nucleus sets fire to the other balls, and the ball in the center bursts and scatters the others, which fire in the time it takes to say an Ave Maria (*Codex Atlanticus*).

## Leonardo's letter to Ludovico il Moro

*The letter that Leonardo wrote to the ruler of Milan in about 1482 was a catalogue of his skills, especially in military engineering: a sort of Renaissance résumé. His notebooks preserve a draft (with some of the elements numbered out of order), written out by someone else.*

Most Illustrious Lord, having by now sufficiently considered the experience of those men who claim to be skilled inventors of machines of war, and having realized that the said machines in no way differ from those commonly employed, I shall endeavor, without prejudice to anyone else, to reveal my secrets to Your Excellency, for whom I offer to execute, at your convenience, all the items briefly noted below.

1. I have a model of very strong but light bridges, extremely easy to carry, by means of which you will be able to pursue or if necessary flee an enemy; I have others, which are sturdy and will resist fire as well as attack, and are easy to lay down and take up. I also know ways to burn and destroy those of the enemy.

2. During a siege, I know how to dry up the water of the moats and how to construct an infinite number of bridges, covered ways, scaling ladders, and other machines for this type of enterprise.

3. *Item.* If because of the height of the embankment, and the strength of the place or its site, it should be impossible to reduce it by bombardment, I know methods of destroying any citadel or fortress, even if it is built on rock.

4. I also have models of mortars that are very practical and easy to transport, with which I can project stones so that they seem to be raining down; and their smoke will plunge the enemy into terror, to his great hurt and confusion.

9. And if battle is to be joined at sea, I have many very efficient machines for both attack and defense; and vessels that will resist even the heaviest cannon fire, fumes, and gunpowder.

5. *Item.* I know how to use paths and secret underground tunnels, dug without noise and following tortuous routes, to reach a given place, even if it means passing below a moat or a river.

6. *Item.* I will make covered vehicles,

safe and unassailable, which will penetrate enemy ranks with their artillery and destroy the most powerful troops; the infantry may follow them without meeting obstacles or suffering damage.

7. *Item.* In case of need, I will make large bombards, mortars, and fire-throwing engines, of beautiful and practical design, which will be different from those presently in use.

8. Where bombardment would fail, I can make catapults, mangonels, *trabocchi,* or other unusual machines of marvelous efficiency, not in common use. In short, whatever the situation, I can invent an infinite variety of machines for both attack and defense.

10. In peacetime, I think I can give perfect satisfaction and be the equal of any man in architecture, in the design of buildings public and private, or to conduct water from one place to another.

*Item.* I can carry out sculpture in marble, bronze, and clay; and in painting can do any kind of work as well as any man, whoever he be.

Moreover, the bronze horse could be made that will be to the immortal glory and eternal honor of the lord your father of blessed memory and of the illustrious house of Sforza.

And if any of the items mentioned above appears to anyone impossible or impractical, I am ready to give a demonstration in your park or in any other place that should please Your Excellency—to whom I recommend myself in all humility (*Codex Atlanticus*).

### Flight

*Leonardo's ornithopter had articulated wings. His designs for parachutes and gliders were far more plausible. A recent experiment with a model of a glider succeeded, with only slight modifications.*

Man when flying must stand free from the waist upwards so as to be able to balance himself as he does in a boat so that the centre of gravity in himself and in the machine may counterbalance each other, and be shifted as necessity demands for the changes of its centre of resistance (*Codex on the Flight of Birds*). If you want to see a real test for the wings, make a wing from paper with a net and cane structure 20 armlengths long and wide [around 12 meters], and attach it on a plank which weighs 200 pounds; and apply...a sudden force. And if the 200-pound plank lifts itself before the wing descends then the trial can be considered successful; but be sure that the force is rapid and if the above effect is not obtained, waste no more time on it (*Codex Atlanticus*).

### An alarm clock

*Leonardo loved clocks and clockwork mechanisms of all sorts. Here he proposes*

a clock to be used by those who grudge the wasting of time. And this is how it works:—when as much water has been poured through the funnel into the receiver as there is in the opposite balance this balance rises and pours its water into the first receiver; and this being doubled in weight jerks violently upwards the feet of the sleeper, who is thus awakened and goes to his work (*Manuscript B*).

### Astronomy

*Some of Leonardo's most extraordinary ideas and observations anticipate the discoveries of Galileo by a century. He imagined a telescope and began to see the structure of the solar system:*

The earth is not in the center of the Sun's orbit nor at the center of the

universe, but in the center of its companion elements, and united with them. And any one standing on the moon, when it and the sun are both beneath us, would see this our earth and the element of water upon it just as we see the moon, and the earth would light it as it lights us (*Manuscript F*). Make glasses [i.e., telescopic lenses] in order to see the moon large.... Measure the size of the sun, knowing the distance (*Codex Atlanticus*). Take a sheet of paper and make holes in it with a knitting-needle and look at the sun through these holes (*Codex Trivulzianus*). The sun does not move (*Windsor Castle Royal Library*).

## Alchemy

*Leonardo was severely critical of the pseudosciences and the occult: astrology, necromancy, chiromancy, and alchemy. Yet, he acknowledged that the latter was respectable when it approached chemistry; he was in fact interested in distillation, drew stills, and described how to make them of porcelain.*

But of all human discourses that which must be considered as most foolish which affirms a belief in necromancy, which is the sister of alchemy, the producer of simple and natural things, but is so much more worthy of blame than alchemy, because it never gives birth to anything whatever except to things like itself, that is to say lies; and this is not the case with alchemy, which works by the simple products of nature, but whose function cannot be exercised by nature herself, because there are in her no organic instruments with which she might be able to do the work which man performs with his hands, by the use of which he has made

glass, etc. But this necromancy...is the guide of the foolish multitude... and they have filled whole books in affirming that enchantments and spirits can work and speak without tongues...and can carry the heaviest weights, and bring tempests and rain, and that men can be changed into cats and wolves and other beasts, although those first become beasts who affirm such things (*Windsor Castle Royal Library*).

## Mathematics

*Leonardo perfected systems for measuring distances on land and sea. He estimated the diameter of the earth at about 7,750 miles (12,500 km)—and was not too far off. Before he met the mathematician Luca Pacioli, he had trouble with simple arithmetic: he wrote that "odd numbers have no square root" (Codex Atlanticus). Here he writes on the concept of zero, in rather philosophical terms:*

Every quantity is intellectually conceivable as infinitely divisible. Amid the vastness of the things among which we live, the existence of nothingness holds the first place; its function extends over all things that have no existence, and its essence, as regards time, lies precisely between the past and the future, and has nothing in the present. This nothingness has the part equal to the whole, and the whole to the part, the divisible to the indivisible; and the product of the sum is the same whether we divide or multiply, and in addition as in subtraction; as is proved by arithmeticians by their tenth figure which represents zero; and its power has not extension among the things of Nature (*Codex Arundel*).

# Leonardo in the modern age

*The passion for all things Leonardesque reached its height in the 19th century and its echoes continue to run through the culture of today. In particular, artists cannot resist the* Mona Lisa's *allure. Her legendary indirect gaze provokes a reaction known as the Mona Lisa syndrome: the viewer is enchanted by her smile, which becomes increasingly enigmatic and indefinable, transforming the painting as a whole into a mysterious mirror.*

*Like so many before him, the poet Paul Valéry (1871–1945) was captivated by the personality of Leonardo. In an essay he explores the profound effect Leonardo has had on a modern artist's view of the world.*

I was ravished to the heights of my being by this Apollo [Leonardo]. What could be more alluring than a God who repudiates mystery, who does not erect his authority on the troubles of our nature, nor manifest his glories to what is most obscure, sentimental, sinister in us? who forces us to agree rather than to submit, whose mystery is self-elucidation, whose depth an admirably calculated perspective. Is there a better sign of authentic and legitimate power than that it does not operate from behind a veil? Never had Dionysos an enemy more decided, or one so pure or so armoured with light as this hero, who was less concerned to rend and destroy dragons than to examine the springs of their activity; disdaining to riddle them with arrows when he could riddle them with questions: their superior rather than their vanquisher, he represents less an assured triumph over them than perfect comprehension of them—he understood them almost to the point of being able to reconstruct them; and once he had grasped the principle at work, he could leave them, having mockingly reduced them to the mere category of special cases and explained paradoxes....

Is it not the chief and secret achievement of the greatest mind to isolate [a] substantial permanence from the strife of everyday truths? Is it not essential that in spite of everything he shall arrive at self-definition by means of this

In 1914 the Russian radical painter Kazimir Malevich (1878–1935) used the *Mona Lisa* in a collaged painting, x-ing out her face.

pure relationship, changeless amongst the most diverse objects, which will give him an almost inconceivable universality, give him, in a sense, the power of a corresponding universe?

Paul Valéry, *Introduction to the Method of Leonardo da Vinci*, 1894, translated by Thomas McGreevy

## Giocondomania

*The* Mona Lisa *has always been lionized as a peerless work of art. Its ascendence to mythic status began with Vasari's meticulous but fanciful description, in which he insisted upon nonexistent details such as eyelashes. In the 18th century the Marquis de Sade saw it as the "very essence of femininity." For the 19th-century Romantics it was an archetypal image, ineffable and ambiguous.*

The painter may have been merely the slave of an archaic smile, as some have fancied, but whenever I pass into the cool galleries of the Palace of the Louvre, and stand before that strange figure "set in its marble chair in that cirque of fantastic rocks, as in some faint light under sea," I murmur to myself, "She is older than the rocks among which she sits; like the vampire, she has been dead many times, and learned the secrets of the grave; and has been a diver in deep seas, and keeps their fallen day about her; and trafficked for strange webs with Eastern merchants; and, as Leda, was the mother of Helen of Troy, and, as St. Anne, the mother of Mary; and all this has been to her but as the sound of lyres and flutes, and lives only in the delicacy with which it has moulded the changing lineaments, and tinged the eyelids and the hands." And I say to my friend, "The presence that thus so strangely rose beside the waters is expressive of what

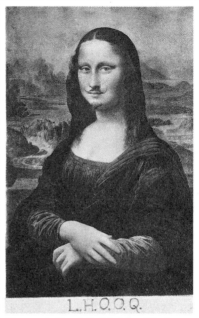

L.H.O.O.Q.

In 1919 the French Dadaist Marcel Duchamp (1887–1968) put a moustache on a reproduction of the *Mona Lisa* and adorned it with the disrespectful, if obscure, tag "L.H.O.O.Q." (phonetically, in French: *elle a chaud au cul,* she has a hot ass).

in the ways of a thousand years man had come to desire"; and he answers me, "Hers is the head upon which all 'the ends of the world are come,' and the eyelids are a little weary."

And so the picture becomes more wonderful to us than it really is, and reveals to us a secret of which, in truth, it knows nothing, and the music of the mystical prose is as sweet in our ears as was that flute-player's music that lent to the lips of La Gioconda those subtle and poisonous curves.

Oscar Wilde, *The Critic as Artist,* 1890

## Poems, plays, songs

*In 1820 William Wordsworth wrote a sonnet on* The Last Supper; *Dante Gabriel Rossetti followed later in the century with one on* The Virgin of the Rocks. *Jules Verne wrote a play titled* Mona Lisa *in 1874. The film directors Sergei Eisenstein, Andrei Tarkovsky, Salvador Dalì, and Luis Buñuel have introduced the myth of Leonardo into film. And in 1950 Nat King Cole made this pop lyric famous:*

Mona Lisa, Mona Lisa, men have
    named you.
You're so like the lady with the mystic
    smile.
Is it only 'cause you're lonely they have
    blamed you
For that Mona Lisa strangeness in your
    style?
Do you smile to tempt a lover, Mona
    Lisa?
Or is this your way to hide a broken
    heart?
Many dreams have been brought to
    your doorstep;
They just lie there and they die there.
Are you warm, are you real, Mona Lisa?
Or just a cold and lonely, lovely work
    of art?
        *Mona Lisa,* lyrics by Jay Livingston
                    and Ray Evans, 1949

## Leonardo in prose

*A contemporary writer, Guy Davenport, envisions the artist at work:*

[Leonardo] moved the bucket of grasses which Salai had brought him from Fiesole.…Meadow grass from Fiesole, icosahedra, cogs, gears, plaster, maps, lutes, brushes, an adze, magic squares, pigments, a Roman head Brunelleschi and Donatello brought him from their

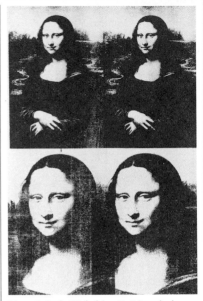

In 1963 Andy Warhol (1928?–87) made the *Mona Lisa* into one of his icons of mass production, endlessly repeated.

excavations, the skeleton of a bird: how beautifully the Tuscan light gave him his things again every morning, even if the kite had been in his sleep.

Moments, hour, days. Had man done anything at all?

The old woman had brought the wine and the bread, the onions. He and Toscanelli, Pythagoreans, ate no meat.

The machine stood against the work-table, the *due rote,* unaccountably outrageous in design. Saccapane the smith was making the chain that would span the two *rote dentate.* You turned the pedals with your feet, which turned the big cog wheel, which pulled the chain forward, cog by cog, causing the smaller wheel to turn the hind *rota,* thereby propelling the whole machine forward.

As long as the machine was in motion, the rider would balance beautifully. The forward motion stole away any tendency to fall right or left, as the flow of a river discouraged a boat from wandering.

If only he knew the languages! He could name his machines as Archimède would have named them, in the ancient words. He called his flying machine the bird, *l'uccello*. Benedetto said that the Greeks would have called it an *ornitottero,* the wings of a bird.

Light with extravagance and precision, mirror of itself *atomo per atomo* from its dash against the abruptness of matter to the jelly of the eye, swarmed from high windows onto the two-wheeled balancing machine. The rider would grasp horns set on the fork in which the front wheel was fixed and thus guide himself with nervous and accurate meticulousness. Suddenly he saw the Sforze going into battle on it, a phalanx of these *due rote* bearing lancers at full tilt. *Avanti O Coraggiosi, O!* the trumpet called, *tambureggiandi le bacchette delli tamburi di battaglia.*

The scamp Salai was up and about.

—*Maestro!* he piped. You've made it!

Leonardo picked up the brown boy Salai, shouldered him like a sack of flour, and danced the long gliding steps of a sarabande.

—*Si, Cupidello mio, tutto senonchè manca la catena.*

—And then I can make it go, ride it like a pony?

—Like the wind, like Ezekiel's angel, like the horses of Ancona.

Salai squirmed free and knelt before the strange machine, touching the pedals, the wicker spokes, the saddle, the toothed wheels around which the chain would fit, *i vinci.*

—*Como leone!*

He turned to the basket of flowering grasses, reaching for his silver pencil. Bracts and umbrels fine as a spider's legs! And in the thin green veins ran hairs of water, and down the hairs of water ran light, down into the dark, into the root. Light from the farthest stars flowed through these long leaves. He had seen the prints of leaves from the time of the flood in mountain rocks, and had seen there shells from the sea.

—Maestro, Salai said, when will the chain be ready?

—Chain? Leonardo asked. What chain?

He drew with his left hand a silver eddy of grass. It was grace that he drew, perfection, frail leaves through which moved the whole power of God, and when a May fly lights on a green arc of grass the splendor of that conjunction is no less than San Gabriele touching down upon the great Dome at Byzantium, closing the crushed silver and spun glass of his four wings around the golden shaft of his height.

—The chain, Salai said, the chain! Did man know anything at all?

Guy Davenport, "The Richard Nixon Freischütz Rag," *Da Vinci's Bicycle,* 1979

A sketch of a bicycle—by Leonardo himself?

# Further Reading

A NOTE ON LEONARDO'S WRITINGS

*Not all of Leonardo's many notebooks and manuscripts have survived. Of those extant, some have been bound together by later owners and others exist in loose sheets. Some of the most famous manuscripts have come to be known by the name of an early owner—the* Codex Leicester *(private collection),* Codex Arundel *(British Library, London),* Codices Forster I, II, *and* III *(Victoria and Albert Museum, London), and* Codex Trivulzianus *(Biblioteca Trivulziana, Milan). The* Codex Atlanticus *(Biblioteca Ambrosiana, Milan) was assembled in the 16th century into a large-format book similar to an atlas ("atlanticus"), from which it received its name. Others are named for their content: the* Codex on the Flight of Birds *(Biblioteca Reale, Turin) and the* Treatise on Painting *(Vatican Library, Rome; also called the* Codex Urbinas Latinus 1270*). This last was compiled as a book after Leonardo's death and comprises, among other elements, a manuscript sometimes called the* Paragone, *or "comparison of the arts." A number of manuscripts now in Paris, in the Bibliothèque de l'Institut de France, are labeled* Manuscripts A–M *(two of these,* Manuscripts A1 *and* B1, *are also sometimes known as* Ashburnham I *and* II*). The queen of England possesses one of the finest collections of Leonardo drawings and manuscripts, identified as the* Windsor Castle Royal Library *collection. These include a group of notes and drawings on anatomy that were at one time collected in three albums called the* Quaderni, *or* Notebooks A, B, *and* C, *as well as loose sheets of nature studies, drawings of horses, and other subjects. Two codices in the Biblioteca Nacional in Madrid are commonly called* Madrid Manuscripts I *and* II. *Numerous other manuscripts and loose sheets are in many public and private collections, including the Louvre in Paris, the Royal Academy and the British Museum in London, the Ashmolean Museum at Oxford University, the Galleria degli Uffizi in Florence, the Metropolitan Museum of Art and the Pierpont Morgan Library in New York , and the Gallerie dell'Accademia in Venice.*

*Facsimile editions of codices have from time to time been published; among these are important volumes edited by A. Marinoni (Milan, 1980 and Florence, 1976) and C. Pedretti (New York, 1982).*

TRANSLATIONS AND ANTHOLOGIES

*Translated quotations of Leonardo's writings in this book are drawn principally from the editions of E. MacCurdy and J. P. Richter, with occasional passages from the book by M. Cianchi.*

Kemp, M., and Walker, M. (ed. and trans.), *Leonardo da Vinci on Painting,* 1989

MacCurdy, E. (trans.), *The Notebooks of Leonardo da Vinci,* 1938

MacMahon, A. P. (ed.), *Treatise on Painting* (*Codex Urbinas Latinus,* compiled by Francesco Melzi), 2 vols., 1956

Pedretti, C. (ed.), *The Literary Works of Leonardo da Vinci: A Commentary of Jean Paul Richter's Edition,* 2 vols., 1977

Reti, L. (ed.), *The Manuscripts of Leonardo*

*da Vinci at the Biblioteca Nacional of Madrid* [*Madrid Manuscripts I* and *II*], 5 vols., 1974

Richter, J. P. (ed.), *The Literary Works of Leonardo da Vinci* [*The Notebooks of Leonardo da Vinci*], 3d ed., 2 vols., 1970

ON LEONARDO

Aston, M., *Panorama du XV^e siècle,* 1969

Beck, J. H., *Leonardo's Rules of Painting: An Unconventional Approach to Modern Art,* 1979

Beltrami, L. (ed.), *Documenti e memorie riguardanti la vita e le opere di Leonardo da Vinci,* 1919

Berenson, B., *The Italian Painters of the Renaissance,* rev. ed., 1930

Blunt, A., *Artistic Theory in Italy, 1450–1600,* 1940

Bramly, S., *Leonardo da*

*Vinci: The Artist and the Man,* trans. S. Reynolds, 1991

Burckhardt, J., *The Civilization of the Renaissance in Italy,* 1961

Chastel, A., *Art et humanisme à Florence au temps de Laurent le Magnifique,* 1952

Cianchi, M., *Leonardo's Machines,* trans. L. Goldenberg Stoppato, 1984

Clark, K., *Leonardo da Vinci: An Account of His Development as an Artist,* 1939; rev. and with an intro. by M. Kemp, 1988

Eissler, K. R., *Leonardo da Vinci: Psychoanalytic Notes on the Enigma,* 1961

Freud, S., *Leonardo da Vinci and a Memory of His Childhood,* trans. A. Tyson, 1961

Galuzzi, P. (ed.), *Leonardo*

*Engineer and Architect,* exh. cat., 1987

Gombrich, E. H., *Apelles's Heredity,* 1976

——. *New Light on Old Masters,* 1986

Gould, C., *Leonardo: The Artist and the Non-Artist,* 1975

Guerrini, M., *Biblioteca leonardiana, 1493–1989,* 3 vols., 1990

Jaspers, K., *Three Essays,* 1964

Kemp, M., *Leonardo da Vinci: The Marvelous Works of Nature and Man,* 1981

Lacroix, P., *Moeurs, usages et costumes à l'époque de la Renaissance,* 1873

Maiorino, G., *Leonardo da Vinci: The Daedalian Mythmaker,* 1992

Masters, R. M., *Machiavelli, Leonardo, and the Science of Power,* 1996

Monti, R., *Leonardo,* 1966

Pedretti, C. (ed.), *Achademia Leonardi Vinci: Journal of Leonardo Studies and Bibliography of Vinciana,* 8+ vols., 1988–95

Popham, A. E., *The Drawings of Leonardo da Vinci,* 1946, repr. 1973

Posner, K., *Leonardo and Central Italian Art: 1515–1550,* 1974

Reti, L. (ed.), *The Unknown Leonardo,* 1988

Rodonachi, E., *La Femme italienne à l'époque de la Renaissance,* 1907

Røsstad, A., *Leonardo da Vinci: The Man and the Mystery,* trans. A. Zwick, 1995

Shell, J., *Leonardo da Vinci,* 1992

Stites, R. S., *The Sublimations of Leonardo da Vinci,* 1970

Turner, A. R., *Inventing Leonardo,* 1993

Valéry, P., *Introduction to the Method of Leonardo da Vinci,* trans. T. McGreevy, 1929

Vasari, G., *Lives of the Artists,* trans. G. Bull, 1965

Vezzosi, A., *Leonardo scomparso e ritrovato,* exh. cat., 1988

——. *La Toscana di Leonardo,* 1984

CD-ROM

A. Vezzosi, *Leonardo: La pittura digitale,* 1988, rev. ed. 1996

# List of Illustrations

# Index

## Acknowledgments

Alessandro Vezzosi and the publisher wish particularly to thank Agnese Sabato, president of the Associazione Internazionale Leonardo da Vinci–Museo Ideale, for her close collaboration in the creation of this work, as well as Michel Pierre, director of the Institut Français de Florence, for his good counsel.

## Photograph Credits

The publishers wish to thank the museums and private collectors named in the illustration captions and NOTE ON LEONARDO'S WRITINGS (page 150) for graciously giving permission to reproduce works of art and for supplying necessary photographs. Additional photograph credits and copyrights are listed below.

Alinari, Florence 130. Aurelio Amendola 21. Archiv für Kunst und Geschichte, Berlin 12. Canali Photobank, Capriolo, Italy spine. École Nationale Supérieure des Beaux-Arts, Paris 49a. Electa 79. Galleria Mathias Hans 109a, 111a. Kunsthal, Rotterdam 30. C. Maffucci–C. Starnazzi 124c. Roger-Viollet, Paris 127. Réunion des Musées Nationaux, Paris front cover r, back cover, 2–3, 31l, 40, 43b, 50, 55l, 56b, 57, 64b, 76, 84, 100–101al, 110, 110–111, 124c, 125l, 125r, 126a, 126b. Scala, Florence 4–5, 16–17b, 24, 26, 26–27, 27r, 34–35, 36br, 37r, 38l, 38bl, 40, 41b, 42al, 44ra, 44rb, 48, 49b, 56a, 58–59, 67a, 76–77, 78. Soprintendenza per i Beni Artistici e Storici, Florence 33b. Paolo Tosi 20b, 22r. Alessandro Vezzosi 13, 14–15, 16–17a, 40, 103, 109br, 128, 133.

## Picture Copyrights

All rights reserved 7, 9, 13, 14–15, 14b, 16, 16–17a, 18b, 22l, 25, 27l, 28–29, 31r, 32l, 32r, 33c, 34, 36a, 36bl, 37l, 38br, 39a, 39b, 40c, 41a, 42ar, 43a, 44l, 45, 52b–53b, 53, 54a, 55r, 58l, 59, 60, 62, 64a, 65b, 68c, 68b, 69, 70ar, 70b, 72a, 73, 74a, 74b, 80a, 80b, 80br–81bl, 81br, 82, 83, 85a, 85b, 86a–87al, 87ar, 87br, 89a, 89b, 90al, 90ar, 90b–91b, 91a, 94a, 94b, 95al, 95b, 95ar, 96a, 97a, 101ar, 101b, 102al, 102b, 103, 104, 106b–107b, 107a, 108b, 109bl, 109br, 111ar, 111bl, 112br, 121a, 124a, 126a, 126b, 128, 133, 147, 148. Property of the Biblioteca Ambrosiana, © all rights reserved, no reproductions allowed front cover l, 19, 51, 52a–53a, 58rb, 61a, 61b, 63, 66a, 68a, 75, 81a, 88l, 92a, 96c–97c, 116a–117a, 116c, 116b, 117b, 123a, 142, 149. Copyright © ARS, New York 148. Copyright © 1988 Estate of Marcel Duchamp/ARS, New York 147. Reproduced from facsimiles of drawings 18a, 20–21, 22–23, 28, 46a, 46b, 47al, 47ar, 47b, 106a, 108a, 120c, 123b, 132, 134, 136. The Royal Collection © Her Majesty Queen Elizabeth II, all rights reserved 1, 3, 4, 6, 8, 11, 14a, 20–21, 45, 54c, 54b, 65a, 66b, 67b, 70al, 71, 72b, 86b–87bl, 88r, 92b, 92r–93, 98a, 98b, 99, 102ar, 105, 112ar, 112bl, 113, 114a, 114b–115a, 115a, 118b, 118a–119a, 119c, 120b–121b, 122, 135, 137, 139, 140, 141. © The State Russian Museum, St. Petersburg 146.

## Text Credits and Copyrights

Quotations from Leonardo in the text are from his notebooks and codices, in translations listed under FURTHER READING.

Charles Baudelaire, *The Flowers of Evil,* translated by David Paul, New York, New Directions, 1955, 1962. Paolo Giovio, *Leonardo Vincii Vita,* translated by Jean Paul Richter, London, Phaidon, 1883. Giorgio Vasari, *Lives of the Artists,* translated by George Bull, Harmondsworth, Englands, Penguin Books Ltd, 1965. A. Richard Turner, *Inventing Leonardo,* New York, Alfred A. Knopf Incorporated, by permission. Roger D. Masters, *Machiavelli, Leonardo, and the Science of Power,* Notre Dame, Indiana, University of Notre Dame Press, 1996. *Mona Lisa,* lyrics copyright © 1949 by Famous Music Corporation, copyright renewed 1976 by Famous Music Corporation. Sigmund Freud, *Leonardo da Vinci and a Memory of His Childhood,* translated by Alan Tyson, Translation copyright © 1957 by The Institute for Psycho-Analysis. Reprinted by permission of W. W. Norton & Company, Inc. Serge Bramly, *Leonardo: The Artist and the Man,* translated by Sian Reynolds, © HarperCollins Publishers, 1988. By Guy Davenport, from *Da Vinci's Bicycle,* copyright © 1979 Johns Hopkins University Press. Reprinted by permission of New Directions Publishing Corp.

Alessandro Vezzosi, art critic and expert on
Leonardo da Vinci, is author of numerous books,
articles, and exhibition catalogues and has organized many
exhibitions on Leonardo, as well as on Renaissance and
modern art. A native of Vinci, he is founder and director
of its Museo Ideale Leonardo Da Vinci.

Translated from the French by Alexandra Bonfante-Warren

For Harry N. Abrams, Inc.
Editor: Eve Sinaiko
Typographic designers: Elissa Ichiyasu, Tina Thompson
Cover designer: Dana Sloan
Text permissions: Barbara Lyons

**Library of Congress Cataloging-in-Publication Data**

Vezzosi, Alessandro.
    [Léonard de Vinci. English]
    Leonardo da Vinci : the mind of the Renaissance / Alessandro Vezzosi.
        p.       cm. — (Discoveries)
    Includes bibliographical references and index.
    ISBN 0–8109–2809–4 (pbk.)
    1. Leonardo da Vinci, 1452–1519.  2. Artists—Italy—Biography.  I. Title.
    II. Series: Discoveries (New York, N.Y.)
    N6923.L33V4913  1997
    709'.2
    [B]—DC21                                                              97–5747

Printed and bound in Italy by Editoriale Libraria, Trieste